LISA COMFORT'S

SEW
OVER
IT
VINTAGE

PHOTOGRAPHY BY TIFFANY MUMFORD

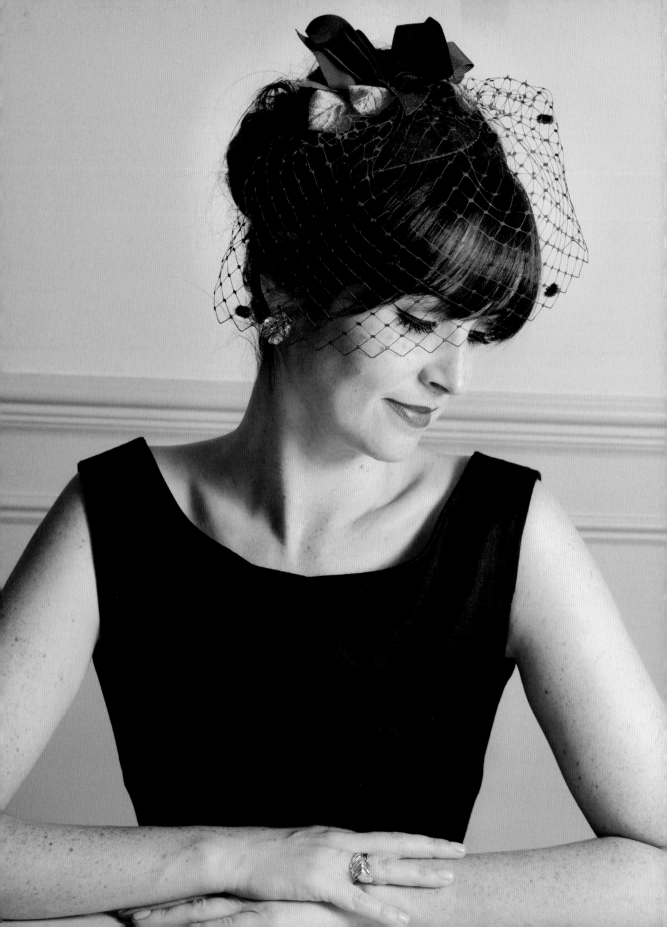

LISA COMFORT'S

SEW OVER IT

Vintage

STYLISH PROJECTS FOR THE MODERN WARDROBE & HOME

EBURY PRESS

Contents

Introducing myself

If my first passion is sewing, then vintage is my second. So there's no surprise that everything I sew, for myself and my home, has a touch of vintage. I count Marilyn Monroe, Grace Kelly and Audrey Hepburn as my fashion idols. What I would have done to have spent a day with their wardrobes! All three women oozed style, elegance and glamour.

So you might have guessed that my favourite fashion decades were the 1950s and 1960s. For me, that was when fashion was at its best. The silhouettes were stunning and the fabrics to die for.

It all began with Christian Dior's first collection for the House of Dior in 1947. Called the New Look, it celebrated soft, feminine style, characterised by small waists, soft rounded shoulders, pointed busts and, most importantly, full skirts. One of Dior's dresses used 15 yards of fabric! Initially, his collection offended many who thought it was an insult to those countries still suffering from post-war austerity measures. However, it soon became very popular and greatly influenced the fashion of the next decade. Dior introduced a richness and sense of luxury.

After many years of cloth restrictions for fashion houses and rationing for everyone else, it was time to be extravagant. And fortunately for us, some of these amazing dresses are still out there for us to enjoy.

That said, dressing completely vintage can be intimidating and you risk looking like a chorus member from a Fred Astaire and Ginger Rogers movie. I don't like feeling too 'costumey' and it just isn't practical. Plus, our figures have changed. Our underwear does not sculpt our busts in the same way and our waists are not as tiny. I think there is so much to learn from the fashion and style of this era, but taking elements and mixing them with what suits you is a better approach. This is what I have done in this book.

Even if my favourite fashion eras were the 50s and 60s, my inspiration for the book spans sixty years of vintage style, from the roaring 1920s to the bohemian 1970s. Whether it's a direct reference to a garment from the 20s, a colour that reminds me of the 60s, or simply making something out of vintage fabric, there is a vintage twist to all the projects that will hopefully complement the rest of your wardrobe.

Last year we were lucky enough to buy our first home and I spent the following 12 months making it our own. We had no budget left for decorating, so making everything myself was essential and, I should add, ever so enjoyable. I have shared some of my favourite projects, both practical and decorative, from my very own home in this book.

I wanted this book to appeal to a wide range of sewists. There are projects for those of you who have recently jumped on the sewing wagon. You can progress through the projects – building up to some of the more challenging garments. I also hope there is plenty in here for those of you who have been sewing for a while and want to try out some basic pattern cutting; there are projects for an afternoon and some for a whole weekend.

I have shared many of the techniques that I have learned over twenty years of sewing, many of which have come from the amazing team of teachers at Sew Over It. I never stop learning! There is no point in keeping these little gems to myself. I want to share them with you and spread the sewing word. I hope you enjoy learning what I have learned and get as much pleasure out of this book as I did writing it.

In your sewing box

SCISSORS

Spend some money on a good pair of fabric scissors. Look after them by not dropping them, not cutting through pins with them and not sharing them. It sounds mean, but we all cut at different angles, so sharing them can blunt them.

Keep another pair of scissors that are just used for cutting paper. This will keep them sharp. Whatever you do, don't use your fabric scissors to cut paper!

When you're sewing, keep a little pair of scissors to hand to cut threads.

TAPE MEASURE

This is usually around my neck the whole time I am sewing. Not as a fashion accessory, but so that I can whip it out for reference whenever I need it.

UNPICKER

You hope you won't need this, but you probably will. Just like scissors, they can get blunt, so replace them as often as you need. It will make your mistakes a lot less painful.

PINS

At Sew Over It we use lovely long pins with round heads. They make pinning a lot easier. But for delicate fabrics such as fine silks, you should use silk pins which are much finer.

HAND-SEWING NEEDLE

Everyone has a preference here. Some prefer short and others long, but for beautiful hand stitches the needle must be fine, otherwise it will be hard to keep those stitches neat and tidy.

TAILOR'S CHALK

There are some great products on the market now that dispense tailor's chalk in a fine line. Check out the pens and wheels available. You can also buy air-erasable pens, which I love, as you can be so accurate with them. Of course, you can also use good old-fashioned tailor's chalk triangles. Just keep them as sharp as you can. I often break mine into small pieces if I need to make a sharp edge.

THREAD

For both hand- and machine-sewing, I prefer to use polyester thread. Buy as good a quality thread as you can afford and your machine will thank you. Cheaper threads will snap more easily.

Glossary of stitches

HAND-SEWING STITCHES

STARTING OFF

Tie a knot in the end of the thread when starting off and do a little secure stitch into the fabric. Never rely on just a knot.

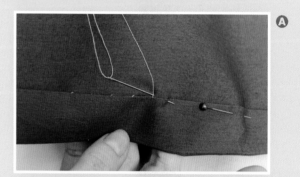

SLIP STITCH

This is a discreet stitch often used to anchor down facings or linings. On the surface you make only a small stitch, catching the edge of the fold, then move along underneath. **A**

OVERSTITCH

Use when sewing over an edge or fold. **B**

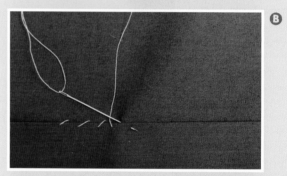

BACKSTITCH

It's like a running stitch but you go back on yourself and fill in the gaps in between the stitches, making the seam stronger. **C**

HAND HEMMING STITCH

Hand hemming allows you to alternate between the edge of the hem and the inside garment. When stitching through the hem, make a small stitch. When stitching through the garment, take only a few strands so it doesn't show. **D**

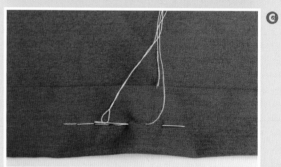

FINISHING OFF

Finish with a secure stitch and a magic knot which sits flush against the fabric.

MACHINE STITCHES

OVERLOCK STITCH

Using a 3 or 4 thread overlocker, stitch the raw edge to bind and prevent fraying. **E**

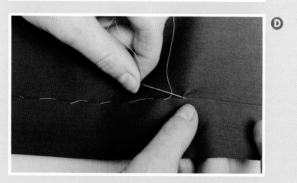

ZIGZAG STITCH

This stitch is used for both appliqué and to finish seams. For finishing seams, the zigzag must sit on the edge so that it wraps around to bind the edge. **F**

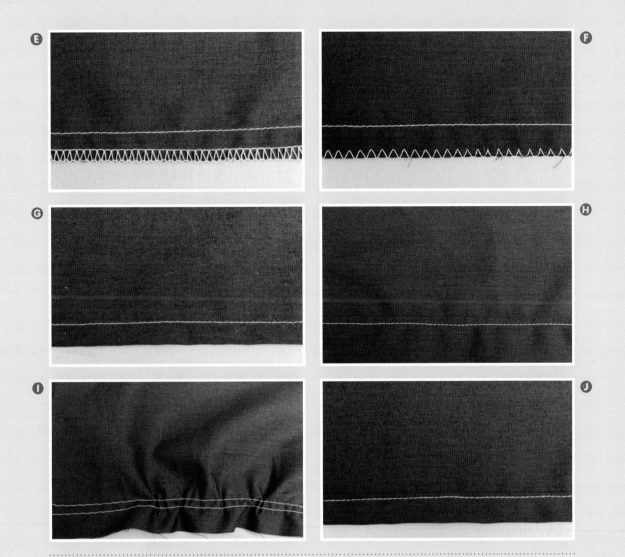

TOP STITCH

A top stitch is often used to finish a neckline or hem. You stitch from the right side, usually close to the edge. **G**

EDGESTITCH

This is used to stitch hems. It must be about 2-3 mm (1/8-3/16 in) from the edge. **H**

SINK STITCH

Also referred to as 'stitch in the ditch', this is a form of top stitch that sits right in the seam join so it can't be seen.

GATHER STITCH

Made up of two parallel rows of long machine stitches that sit within the seam allowance. In order to pull the thread ends together to gather up the fabric, you do not backstitch at beginning or end. **I**

UNDERSTITCH

Understitch is used to help the facing or lining stay inside the garment. You stitch about 2-3 mm (1/8-3/16 in) from the seam (joining the facing or lining to the garment) on the facing or lining side, anchoring it to the seam allowance. **J**

STAY STITCH

A single line of straight stitching through one layer to stabilise the fabric and prevent stretching. It must be within the seam allowance so that it doesn't show.

How to measure yourself

TOP TIPS WHEN MEASURING

❶ Make sure you are wearing only a thin layer of clothing or better still only underwear.

❷ Keep the tape measure level if measuring around yourself.

❸ Ask a friend to help you or, failing that, measure yourself in front of a full-length mirror so that you can make sure you are measuring at the right places.

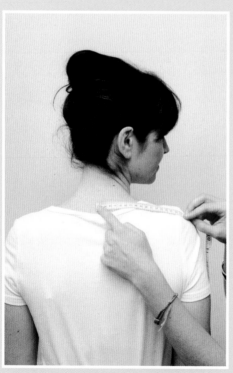

FROM NAPE TO SHOULDER SEAM.

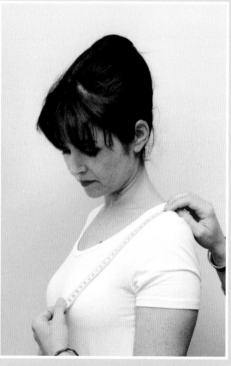

SHOULDER SEAM TO FULLEST POINT ON YOUR BUST (BUST POINT).

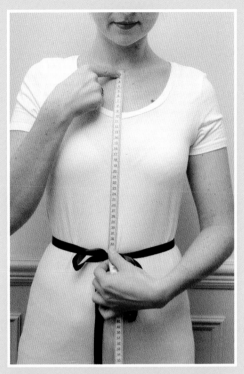

FROM CENTRE OF COLLARBONE TO WAIST.

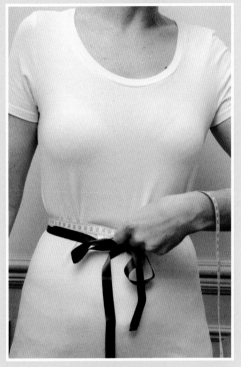

WAIST CIRCUMFERENCE.

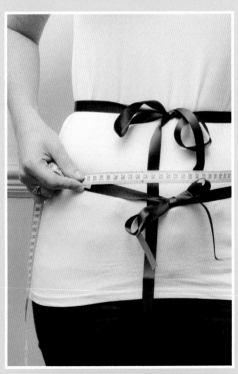

TOP HIP CIRCUMFERENCE.

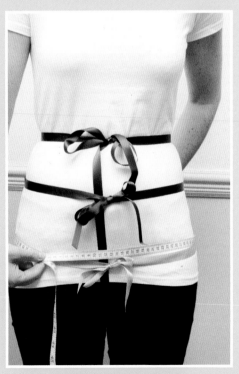

LOWER HIP CIRCUMFERENCE.

Pattern-cutting tools

A LOT OF THE PROJECTS IN THE BOOK REQUIRE YOU TO MAKE
THE PATTERNS YOURSELF. THIS IS THE KIT YOU WILL NEED.

PATTERN PAPER

Throughout the book I use dot and cross paper, which is designed for industry and therefore can often only be bought on a massive roll. If you don't want to invest in enough paper to last you a lifetime, then pick up some large sheets from a craft shop. The thinner the better, as you need to be able to pin through it.

PATTERN MASTER

This is almost essential. It makes pattern cutting so much easier. It is a special ruler designed for pattern cutting. We use it for lots of things, but for drawing right angles and for adding seam allowances, it makes life a lot easier.

METRE RULE

Some of the patterns require you to draw long lines, longer than the pattern master. It is much easier and more accurate to do this with a metre rule.

SHARP PENCIL

Sounds silly but if your pencil isn't sharp then your markings could be off. I use a 'clicky' (mechanical) pencil to ensure my lead is always sharp.

MASKING TAPE

You will need this for the projects where you cut and slash open the patterns and then stick them back together again. Masking tape is a lot better than sticky tape as it isn't permanent, so you can re-adjust it as necessary. You can also draw over it with pencil, which is important for pattern cutting.

Introduction to pattern cutting

HERE IS AN EXPLANATION OF SOME OF THE TERMS I WILL BE REFERRING TO IN THIS BOOK.

A

B

C

BLOCK

A block is a basic pattern from which other patterns are made. In the book I show you how to make a basic bodice block to your measurements that you can go on to use as a starting point for three other tops/dress.

TOILE

A toile is a mock-up of a garment made in a cheap fabric such as calico. A toile is used to check the pattern fits properly before using your best fabric. In the book I suggest you make a toile of your bodice block to check that it fits. Ⓐ

GRAINLINES

The grainline is a long straight line on the pattern, often with an arrow at either end that indicates how to position the pattern piece on the fabric. The grainline should always sit parallel to the selvedge of the fabric. Grainlines are on every pattern and therefore you must add them to the patterns you will be drafting. Don't worry, I will always tell you where to put them. Ⓑ

FOLDLINES

If a pattern piece needs to be cut on the fold, you indicate the edge that must be positioned on the fold with a foldline. It is a straight line, parallel to the pattern edge, with two arrows extending either side, pointing towards the edge. Again, I will tell you where you need to add a foldline. Ⓒ

ANNOTATING YOUR PATTERN

You must annotate your pattern with various bits of information to help you when cutting out. You will need to add:

1. The style of the pattern, e.g. Anita tie top.
2. The cutting instructions (which I will tell you).
3. The name of the pattern piece, e.g back bodice.

MANIPULATING THE BLOCK

We will sometimes need to change the shape of the pattern. To do this we use a technique called slashing. Slashing is when you draw a straight line on the pattern and then cut along that line, leaving a small amount uncut so that you can pivot from that point (like a hinge) to move the pattern and in turn to change its shape.

NOTCHES

Notches are added to the pattern to help you to line up two pieces together or to show you where to start or stop stitching. To mark a notch draw an upside down 'T'.

FACINGS

A facing is a pattern piece that mirrors the edge of a garment. Often used for necklines, they are used to finish the edge and sit inside the garment.

EASE

Ease is what makes our clothes comfortable to wear. Without this everything would be skin tight. A close-fitting garment has about 5 cm (2 in) ease. A loose-fitting garment will need double this amount of ease.

SQUARE OUT/ ACROSS/ DOWN

This means you need to draw a line that is perpendicular to another line or point.

Cutting guidelines

HERE ARE SOME POINTERS TO HELP YOU TO CUT OUT YOUR PATTERN PIECES ACCURATELY.

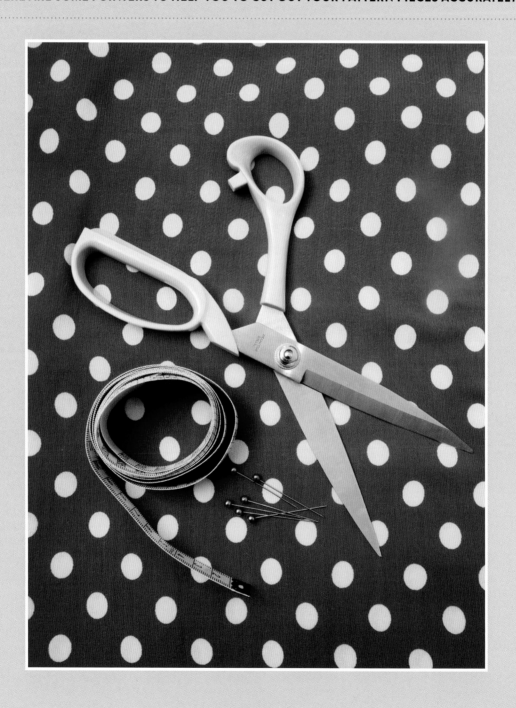

PREPARING THE FABRIC

Always give your fabric a wash or a steam iron before you start. This will pre-shrink the fabric.

LAYING OUT THE FABRIC

It is important to use a work surface that is big enough to lay out the fabric properly. If you don't have a big enough table, use the floor!

If you need to cut 'a pair', 'two' or 'one on the fold' of a piece, then you will need to fold the fabric right sides together. The selvedges need to be perfectly aligned and the foldline should be parallel to the selvedge. If the selvedges keep moving apart you can always pin them together.

POSITIONING THE PATTERN PIECES

Make sure you follow the cutting guidelines on the pattern.

'Cut a pair' means you need to cut a left and a right, so each one is a mirror image of the other. If the fabric is folded right sides together then you will automatically do this when cutting two at a time.

'Cut on the fold' means that the foldline on the pattern must sit right on the fold of the fabric. You do not cut along the fold in the fabric.

Make sure that the grainlines are always parallel to the selvedge by using a tape measure. Check the distance at either end of the grainline to the selvedge, and ensure it is the same.

PINNING

Pinning is just as much of an art as sewing or cutting. Correctly positioned pins make cutting a lot easier.

Keep the pins parallel and close to the edge of the pattern.

At a corner, make sure the point of the pin is facing the corner, keeping the paper as flat as possible.

Keep your hands on top, pinning only from the pattern side. If you put your hand underneath the fabric, you risk moving the fabric out of place.

CUTTING NOTCHES

The notches should be marked with an upside-down 'T' on the pattern. Cut along the stem of the T and stop at the bar. This creates a little slit. The notch should always be less than the seam allowance.

FABRIC ALLOWANCE

For the garment projects you will need to calculate your own fabric allowance. Do this by marking out the width of the fabric folded as it needs to be. I use metre rules or tape measures to set the edges. Position the pattern pieces in the marked-out area, remembering to use the pattern piece twice if you need two pairs. For some of the projects (Anita tie top, 1950s Sally sailor blouse, cowl-neck dress) you will need two foldlines. So fold the fabric so the selvedges meet in the middle, creating a fold on either side.

COLLARS * CUFFS

*

DABBLE
WITH
VINTAGE

*

* BROOCHES *

*Dabble with a
bit of vintage*

Adding Fur Cuffs
& A COLLAR TO A COAT

Attaching faux fur to the collar and cuffs of a coat adds instant fifties glamour. It will also give your coat a completely new look. For this project, I used faux fur with quite a long pile.

YOU WILL NEED

★ Coat with a plain collar and plain cuffs

★ Approx 30 cm (12 in) of faux fur

LEVEL: INTERMEDIATE

DRAFTING THE PATTERN

THE COLLAR

1. Following a similar technique to the Peter Pan collar on page 27, you will need to work from the coat to get your pattern. 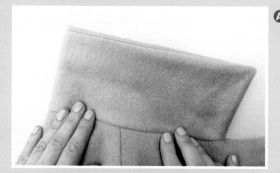 Ⓐ

2. Find the centre back of the collar – there is often a centre back seam on the undercollar – if so, use this. If not, fold the collar in half and mark the centre with a line of pins.

3. Draw a straight line on a piece of paper. Place the centre back collar edge onto this line. Keep the collar as flat as possible so that you get the true shape. Trace around the outer edge of the collar up to the centre back. 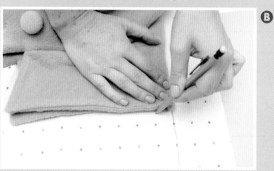 Ⓑ

4. Remove the coat from the paper and smooth out the traced line.

5. At regular intervals along the collar, measure from the outer edge to the neckline, transferring these measurements onto the pattern paper, creating a dashed line. Connect the points in a smooth line to complete the shape of the collar.

6. Where the outer and neckline edges meet the centre back line there must be a right angle. Cut out the shape.

7. Fold another piece of paper in half and trace around the collar pattern. The centre back edge should sit on the foldline.

8. Add 1 cm (½ in) to all edges except the foldline/centre back.

9. Cut out through both layers of paper so that you have a whole collar pattern.

10. The grainline should be parallel with the centre back.

THE CUFF

11. Measure around the sleeve hem of your coat **❶**. Then decide how wide you want the cuff to be **❷**.

12. On a piece of paper draw rectangle that measures **❶** x **❷**.

13. Add 1 cm (½ in) to all edges.

14. Label one of the long edges 'TOP' and the other 'HEM'.

15. The grainline should be parallel to the width of the cuff.

CUTTING OUT

16. Following the tips for using faux fur on page 107, cut out the pieces. You will need two cuff pieces and one collar piece. When cutting the collar, think about the pile of the faux fur. You want the pile to go down from the neckline of the collar to the collar edge. On the cuffs it should go down from the top of the cuff to the hem.

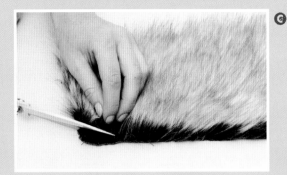

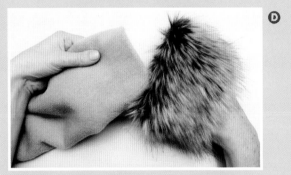

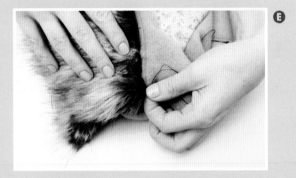

MAKING

Seam allowance is 1 cm (½ in).

17. Trim the fur away along the 1 cm (½ in) seam allowance on all edges. **C**

CUFFS

18. Place the two shorter ends right sides together and pin in place. Stitch in place with the machine.

19. Fold the 1 cm (½ in) seam allowance along the top edge. Pin and hand tack in place. Use a contrasting thread so the tacking is easy to unpick.

20. Slot the cuff onto the sleeve, aligning the sleeve hem with the cuff hem along the top and bottom edges. **D**

21. Pin in place and slip stitch to the coat.

COLLAR

22. Fold over the 1 cm (½ in) seam allowance around all edges and hand tack in place as you did for the cuff.

23. Pin the fur collar on top of the existing collar. Slip stitch around all edges, securing the fur collar to the coat. **E**

Vintage Brooch Embellishment

USING BROOCHES TO DECORATE A NECKLINE

This turns a plain jumper from day wear into evening wear. I love old brooches but I feel a bit dated wearing them on their own as a brooch. Or maybe I'm just a magpie and one simply isn't enough!

YOU WILL NEED
- ★ A few vintage brooches that complement each other
- ★ Fusible interfacing
- ★ Nylon/Nymo thread
- ★ Pliers

LEVEL: EASY

1. Remove all the clasps and pins from the back of the brooches with pliers.

2. Arrange the brooches on the neckline of the garment. Once you have decided on the position, mark the outline with safety pins. Ⓐ

3. Using the safety pins as a guide, cut a piece of fusible interfacing that is slightly bigger than the area. Use this as a template to cut a second piece. Ⓑ

4. Iron the first piece of interfacing to the wrong side of the garment.

5. Position the brooches on the right side of the garment and, with a double thread, anchor them down with some big tacking stitches. You can use regular thread for this. Ⓒ

6. Then taking a needle and nylon thread, start to work your way discreetly around one brooch at a time, catching the edges with little overstitches. Do at least two stitches at each anchor point, carrying the thread underneath the garment to the next point. If you run out of thread, make sure you do a little secure stitch and then a knot before cutting the thread.

7. You can then iron on the second piece of interfacing over the back of the stitching, to prevent the thread from catching your underwear.

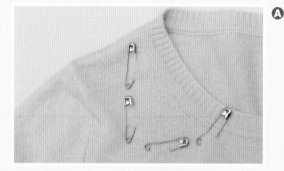

Ⓐ

Ⓑ

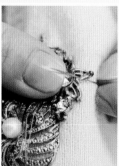

Ⓒ

Adding a Peter Pan Collar
TO AN EXISTING NECKLINE

You can add a little bit of sixties style to any top or dress by adding a Peter Pan collar. In the sixties, Peter Pan collars were much bigger than this one but today that would look too costumey.

YOU WILL NEED

★ A top or dress with a plain round neck – the fabric must not be too thick. I am using our Ultimate Shift dress. Unpick the seam around the neckline, or if there is a facing, you will need to unpick this. Press the seam allowance flat.

★ Approx. 20 cm (8 in) of woven fabric. I used cotton.

LEVEL: INTERMEDIATE

DRAFTING THE PATTERN

1. Take your dress/top, fold in half vertically, and pin the neckline together along the shoulder seams. You can then find the centre front and centre back of the neckline. Mark with a pin.

2. Draw a straight line on a piece of paper. Lay the centre front neckline of the dress against the line drawn on the paper. It is important that the neckline sits as flat as possible to get the true shape.

3. With a pencil, draw around the neckline and along the centre back. Mark the shoulder seam with a notch.

4. Smooth out the curve you have just traced and with a ruler straighten the centre back line.

5. Label the straight edges 'CENTRE FRONT' and 'CENTRE BACK' respectively. Label the curved edge 'NECKLINE'.

6. Then measure down 4.5 cm (1¾ in) from the neckline in regular intervals.

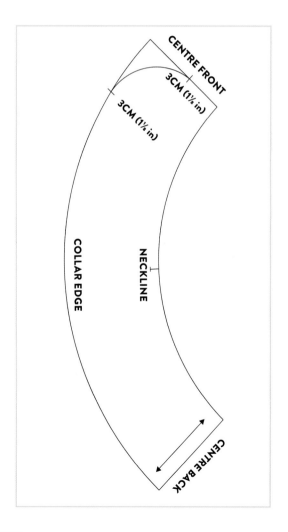

Join these points in a smooth dashed line. Label this 'COLLAR EDGE.'

7. From the centre front, measure back 3 cm (1¼ in) along the bottom collar edge and measure up 3 cm (1¼ in) on the centre front edge. Join these points in a smooth curved line. Alternatively you can make your collar pointed by drawing a diagonal line from the centre front neckline to the collar edge and then straightening the collar edge to form a point.

8. Add a 1 cm (½ in) seam allowance to all the edges except the neckline which should follow the existing seam allowance on the garment.

9. The straight grainline should be parallel to the centre back.

FACING

If your dress or top already has a facing, you don't need to do this stage.

10. To finish the edge of the neckline you can use a facing. To create a facing, trace off the same shape used for the collar (without seam allowances). Where the neckline and bottom edge (the collar edge) meet the centre front there must be a right angle.

11. At the notch marking the shoulder seam, draw a line, separating the piece into the front facing and the back facing.

12. The front facing is normally cut on the fold, with the foldline at the centre front. The back facing is normally two pieces as there is often an opening at the centre back of garments. But if your top or dress does not have an opening, this can also be cut on the fold. The centre back would be the foldline.

13. Add a 1 cm (½ in) seam allowance to the bottom edge of the facing and at the shoulder seams. Add 1 cm (½ in) to the centre back if it is not going to be cut on the fold. The seam allowance on the neckline should reflect that of the existing garment.

CUTTING OUT

14. You will need two pairs of the woven fabric to make up your collar.

15. For the facing you will need one front facing piece and either one back piece cut on the fold or a pair.

MAKING

1 cm (½ in) seam allowance for the collar (the neckline seam allowance should follow the existing garment).

16. If your top or dress has an opening then you make the two collar pieces up separately. If there is no opening, you can join the collar pieces at the centre back.

17. Place one collar pair with right sides together and pin along the collar edge, the centre front and the centre back. Ⓐ

18. Stitch in place with a 1 cm (½ in) seam – but don't sew along the neckline edge. Trim the seam allowance to 5 mm (¼ in) and clip around the curve. If you have opted for a pointy collar, then cut the corner at an angle to avoid bulk. Do the same at the centre back.

19. Turn the collar the right way round and press so that the top collar slightly rolls over the edge so you cannot see the seam.

20. Repeat this process with the other pair.

21. Mark the centre front of the neckline on the top or dress and the centre back, if there is no opening. Place the collar around the neckline, aligning the two centre fronts and two centre backs. The notches on the collar should sit on the shoulder seam of the top or dress. Pin in place and machine tack with a 7 mm (⅜ in) seam allowance.

TO FINISH WITH A FACING

22. If your neckline already had a facing follow steps 25–28 to re-attach it.

23. Place the front and back facings together at the shoulder seams. Pin and stitch in place. Press the seams open.

24. Overlock or zigzag the bottom edge of the facing.

25. Place the facing right side down on top of the collar, sandwiching the collar between the top or dress and facing. Align the edges and shoulder seams. Turn under the centre back edge of the facing so that it is in line with the back opening (ignore this if the back facing is one piece). Pin and stitch in place using the decided seam allowance (see step 13).

26. Trim the seam allowances of the collar to 5 mm (¼ in) and clip into the curves on both top or dress neckline and collar. Press the seam allowance up towards the facing.

27. Understitch along the facing to help it sit inside the neckline.

28. Press again, this time making sure the collar neckline slightly rolls over to the inside of the dress. **G**

Glam up
A BRETON SHIRT

I am a big fan of the Breton shirt. They were originally designed for the French navy, but in 1917, Coco Chanel used them in her Nautical Collection and suddenly they became chic. Unsurprisingly, they are still a staple item of many of our wardrobes. In this project I show you how to reinvent this classic by adding a little Gatsby glamour.

YOU WILL NEED

★ Old jewellery – strings of beads, necklaces and bracelets that can be cut up or individual beads
★ Beading needle
★ Nymo thread
★ Interfacing

LEVEL: EASY

INTERFACING

If you are going to add a few rows of beads, you will need to interface the neckline of your top to help it support the weight of the beads. I used lightweight fusible interfacing. I cut a shape that was just a little deeper than where the beads would go. Iron this shape onto the back of the shirt.

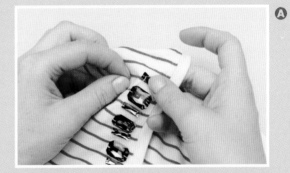

ADDING THE BEADS

Here are three ways that you can use old jewellery. It can be nice to mix up a couple pieces of jewellery to add different colours, size and textures of beads.

SEWING INDIVIDUAL BEADS

1. Cut up the necklace or bracelet and lay the beads along the neckline to decide which combination works best. Once decided, take a photo to use as reference as you are sewing. I recommend not sewing the beads right on the edge of the neckline. Start at least 3 mm (3/16 in) in.

2. Take a needle and single thread and knot the end. Starting with a little secure stitch, bring the needle through to the outside of the dress and thread on the first bead. Then take the needle back down into the dress at the end of the bead. Stitch through the bead twice to make sure it is well attached. Come up again and thread on your next bead and repeat this process until the final bead is in place. Finish off in the same way you started. Ⓐ

3. If you run out of thread, do a little secure stitch and knot off to finish.

SEWING THE BEADS IN A MOTIF

4. I often look for inspiration for sewing beads in a motif. Beading of vintage clothing was a lot more elaborate and detailed than it is today. Often you can pick out an element and use that as a basis for your design. Lay the beads out first to see if the design works with the size and type of bead you plan to use. Then take a photo to use as reference while you are beading.

5. Next transfer the design onto the top. If it is simple, you could mark the position of the beads with pins or for more detailed designs, use an air-erasable pen.

6. Take a needle and single thread and knot the end. Starting with a little secure stitch, bring the needle through to the outside of the top and thread on the first bead. Then take the needle back down into the top at the end of the bead. Come up again and thread your next bead, repeating this process until you reach the end. Finish off in the same way you started.

SEWING ON INDIVIDUAL BEADS IN A ROW

7. If you decide to separate out the necklace or bracelet to use only some of the beads, then you need to sew on each bead individually as above but you will then also need to stitch through them all together on a continuous thread.

8. First stitch each bead on individually as above, securing the thread after each bead has been added.

9. Once all the beads have been sewn on and so that the individual beads all hang evenly, using another length of thread, take the needle through each bead, not stitching into the dress but essentially 're-stringing' the beads. Start and finish the thread with the same secure stitch and knot.

10. You can add as many rows of beads as you want but remember the more you add the heavier the neckline will become. You will need to be confident the neckline won't change shape under the weight of the beads, even with interfacing applied to the wrong side of the fabric.

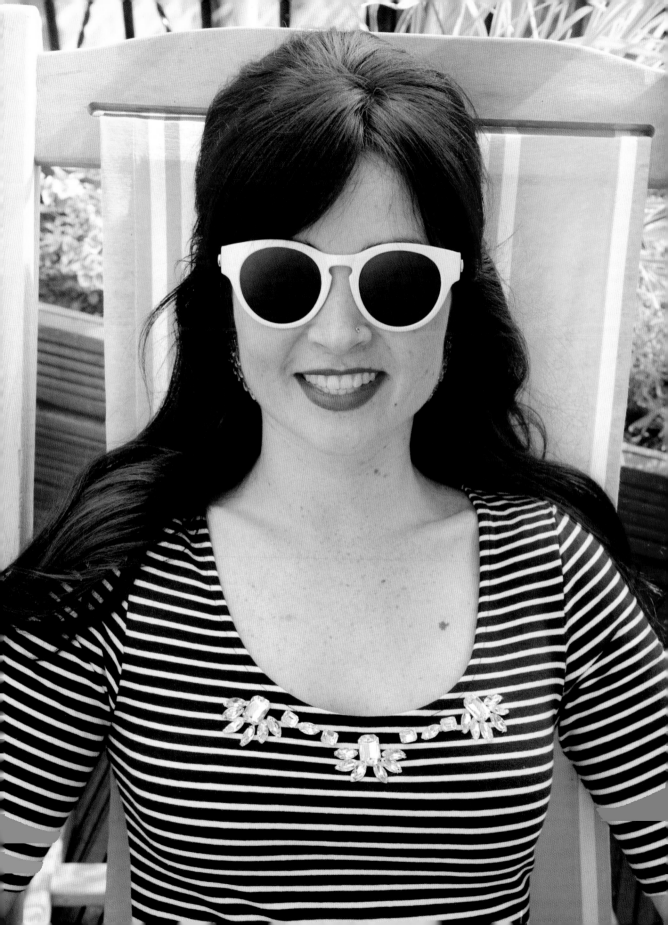

VINTAGE GARMENTS

VINTAGE

1920s
TO
1960s

CARDIE
DRESS

FRENCH
KNICKERS

ANITA
TIE TOP

CAPELET

PLEATED
JERSEY
DRESS

COWL-
NECK
DRESS

SAILOR
TOP

KIMONO
DRESSING
GOWN

CIRCLE
SKIRT

BOX-
PLEAT
DRESS

DRESSES

UNDERWEAR

SKIRTS

TOPS

CAPELET

NIGHTWEAR

Make a vintage-inspired wardrobe

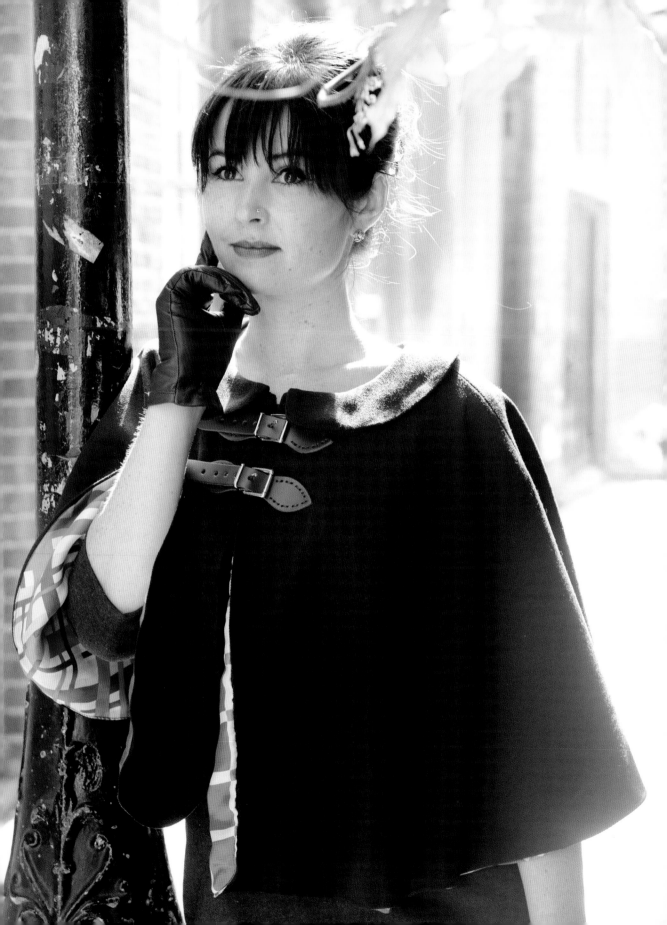

Drafting
YOUR BODICE BLOCK

This is a basic block which is drafted to your measurements. We will use this for a few of the projects in the book. It is meant to be loose fitting. The same pattern is used for the front and back bodice. It is a good idea to make up a toile of the block to check you are happy with it.

MEASUREMENTS REQUIRED

To get accurate measurements you will need to wear a tight t-shirt with a shoulder seam that sits in the middle of your shoulder.
❶ Nape to shoulder seam plus the sleeve length.
❷ Centre of the collarbone to your waist.
❸ Your waist.
❹ Shoulder seam to the fullest point on your bust.
See pages 12–13 for guidance on how to measure.

LEVEL: INTERMEDIATE

PATTERN

1. Take a piece of pattern paper approx. 60 cm x 60 cm (approx. 23¾ in x 23¾ in) and draw a vertical line to the right side of the paper, from the top to the bottom.

2. Starting a few centimetres (1 in) down, square across from this line using your nape to sleeve length measurement ❶, this will become line AB.

3. Then mark down along the vertical line, the measurement from the centre of your collarbone to your waist ❷, creating line AC.

4. Square across from C, the same distance as AB, creating line CD.

5. Square up from D, the same distance as AC. This should resemble a rectangle.

6. Take your waist measurement ❸ and divide it by 4 and multiply by 1.4. From C, mark this distance along line CD, creating point E. Make sure this amount is equal or more than the circumference of your bust plus 10 cm (4 in).

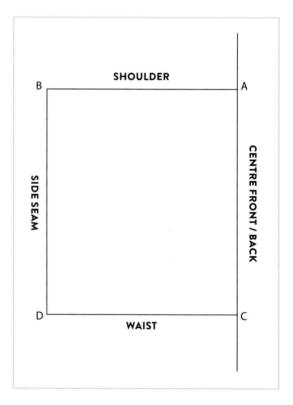

7. Then square up to line AB, creating point F. Line EF must be parallel to AC and BD.

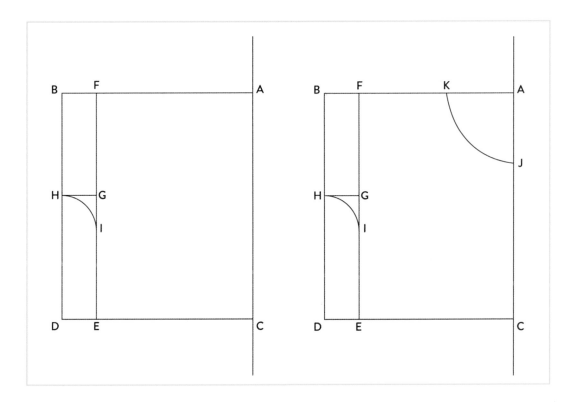

8. Take the measurement from ❹ and subtract 3 cm. This must always be in centimetres. Mark this distance along line EF, starting from F, creating point G.

9. Square across from G to line BD creating point H.

10. From G, mark down 2 cm (¾ in) on line EF and label point I.

11. From point I to H draw a smooth curved concave line. This will become your underarm.

12. Measure down 7 cm (2¾ in) on line AC and mark point J.

13. Measure from A along line AB, 13 cm (5 in) for sizes 8–12, and 14 cm (5½ in) for sizes 14–18 and label K. This sets the width of the neckline.

14. Starting at J, square out 2 cm (¾ in) and continue the line into a smooth curve to meet point K. This is your neckline.

EXCEPTIONS TO THE ABOVE (SEE DIAGRAM ON PAGE 38)

If your waist measurement is larger than the shoulder sleeve width...

15. Still mark point E, but as this will be wider than D, do not square up to F. Instead mark your measurement ❹, minus 3 cm (1 in) on line BD (down from B to D) and label this G.

16. From G, square across 2 cm (¾ in) towards the centre front and label H.

17. From H, square down 2 cm (¾ in) and label I.

18. Join E to I with a diagonal line.

19. From point I to G draw a smooth curved concave line.

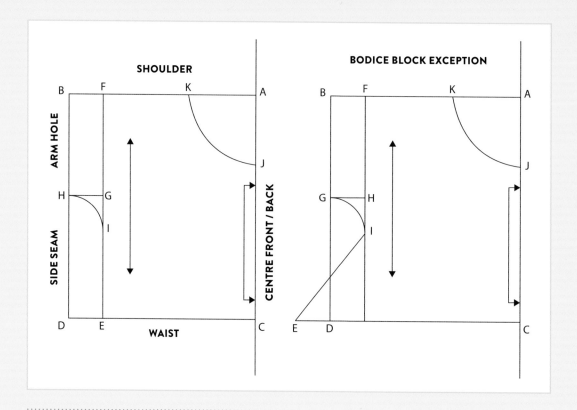

SHOULDER

BODICE BLOCK EXCEPTION

ARM HOLE

SIDE SEAM

CENTRE FRONT / BACK

WAIST

TO FINISH

20. Label 'BODICE BLOCK, FRONT AND BACK BODICE, CUT TWO ON FOLD'.

21. Draw a grainline parallel to line AC.

22. Draw a foldline on line AC and label centre front (CF) / centre back (CB).

MAKING UP A TOILE

23. This block does not have seam allowances. For the toile, trace off the block and then add 1.5 cm (⅝ in) to all edges for seam allowance, except the centre front.

24. Cut out the two pieces in fabric. Join the front and back pieces right sides together at the shoulder seams and the side seams. You do not need to finish the toile. Try on to check it fits! You can then alter as necessary on the pattern but remember it is not meant to be tight fitting.

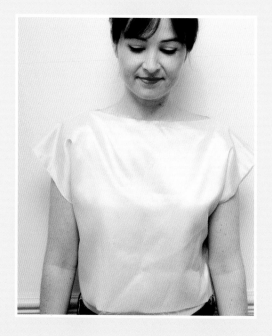

1920s
A N I T A T I E T O P

Inspired by 1920s-style dropped waists, this top is really comfy and looks chic. I wear mine with Capri trousers or jeans. The fabric needs to be lightweight and drapey, so I have used a lightweight silk. For a more contemporary look, use a contrasting colour for the band and ties.

MEASUREMENTS REQUIRED

We are going to use our bodice block as a starting point but we need to lengthen it.

❶ Tie a ribbon around your waist. Then measure down 10 cm (4 in) and tie a second ribbon. Measure around the ribbon. This is your top hip (approx.).

❷ Keeping the ribbon tied around your top hip, measure down 11 cm (4¼ in) and tie a third ribbon here. Measure around this ribbon. This is your lower hip and where the top finishes. If you want to change the length of the top, adjust the distance between each ribbon.

See page 13 for guidance on measuring.

LEVEL: INTERMEDIATE

HOW TO DRAFT THE PATTERN

We will be using the same pattern for the front and back.

BODICE

1. Copy your bodice block.

2. If you want to lower your neck, lower point J. Or make it wider by moving K towards B – this is what I did.

3. Add 10 cm (4 in) to the length of line JC, creating point L.

4. Square across from L and extend line BH to meet this, creating point M. Check that line LM is at least 1 cm (½ in) longer than the top hip measurement ❶ divided by 4. If it isn't, extend line LM from point M until it is.

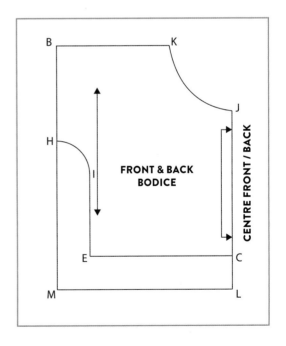

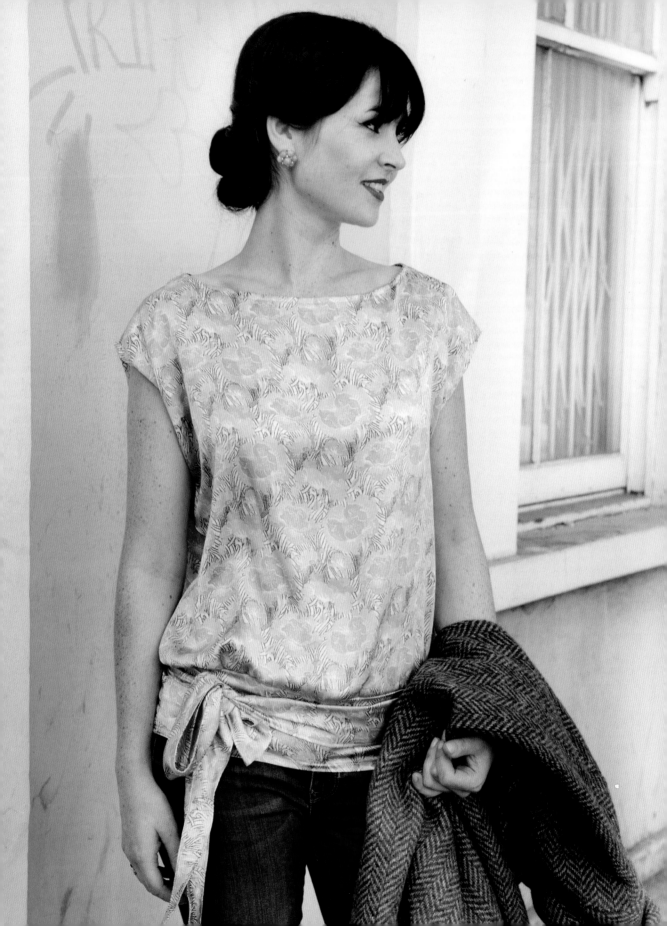

5. BH will create your armhole; however, we are eliminating the underarm curve. This creates a slightly looser fit. H must be marked with a notch so you know where the armhole starts.

EXCEPTIONS TO ABOVE

6. If E on your block is wider than B, follow steps 1–3 only.

7. Then square across from L, in a parallel line to CE that is also the same distance, plus 2.5 cm (1 in), creating point M.

8. Join M to B in a diagonal line.

9. Make sure point G is transferred onto new line MB and mark it with a notch.

TO FINISH

10. Add a 1.5 cm (⅝ in) seam allowance to all the edges except the neckline and foldline where you add 1 cm (½ in).

11. Label the bodice 'FRONT AND BACK BODICE, CUT ONE PAIR'.

12. Copy the foldline and the grainline position from the master block.

BAND

13. Divide your top hip ❶ by 2 and add 1 cm (½ in). Draw a horizontal line that is this measurement; this will be line AB. Mark the centre of this line C.

14. Square down 11 cm (4⅜ in) from C, and label point F.

15. Take your lower hip measurement ❷ and divide by 4 and add 5 mm (¼ in). Starting from F, measure out this distance to the left and then to the right of F and draw a parallel line to AB. Label the points D and E respectively.

16. Join up D to A and E to B.

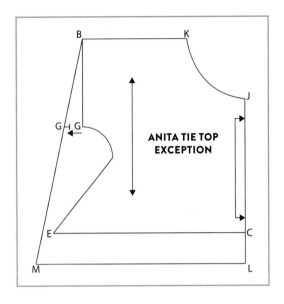

ANITA TIE TOP EXCEPTION

TO FINISH

17. Add 1.5 cm (⅝ in) seam allowance to all edges.

18. Label 'BAND, CUT TWO PAIRS'.

19. Label the shorter edge 'TOP'.

20. Add a grainline perpendicular to the two long edges.

TIES

21. For the ties take the top hip measurement ❶ and multiply by 1.7.

22. Use this measurement to draw a horizontal line – this will be AB.

23. From A, square down by 10 cm (4 in) (width of band minus 1 cm (½ in)), creating line AC.

24. From B, measure back 60 cm (24 in) along line AB creating point E. Square down 10 cm (4 in) from E, creating point D.

25. Join C to D in a line parallel to line AB.

26. Then from D, draw a gently curved line that meets point B.

Diagram

BAND diagram: B — TOP — C — A (top row), E — F — D (bottom row)

TIES diagram: B ... E — TOP — A, D — TIES — C, with "OR" label

A

TO FINISH

27. Add 1.5 cm (⅝ in) seam allowance to all edges.

28. Label 'TIES, CUT TWO PAIRS'.

29. Label line AB 'TOP'.

30. The grainline should be perpendicular to the long edges. This means you will have to use fabric that is 1.4 m (55 in) wide. Alternatively you can put the grainline parallel to the long edges but this will mean a directional print fabric would not work.

BINDING

31. Measure the neckline on the bodice pattern (without seam allowances) and multiply by 4.

32. Cut a strip of fabric on the bias, measuring 3 cm (1⅛ in) wide and as long as the neckline you just calculated, plus 2 cm (¾ in) to allow for finishing the ends.

CUTTING OUT

33. Bodice – cut two on the fold.

34. Band – cut one pair.

35. Ties – cut two pairs.

MAKING

The seam allowance is 1.5 cm (⅝ in) except for the neckline which is 1 cm (½ in).

ADDING THE BAND TO THE BODICE

36. Gather the bottom edge of the front and back bodices. Pull the gathers to half of your top hip measurement and then tie a knot in the thread ends. Evenly distribute the gathers. **A**

37. Place the top edge of the band right sides together with the gathered edge of the bodice. Pin and stitch in place. Overlock or zigzag the seams and press up towards the bodice. Repeat with the back band and bodice. **B**

MAKING AND ADDING THE TIES

38. Keeping one pair of ties right sides together, pin in place and stitch along the long edges, keeping the short, straight edge open. Trim down the seam allowance and cut off the point at the end. Turn right way round. **C**

39. Press flat, keeping the seams right on the edge. Tease the point using a pin. **D**

40. Repeat with the other pair of ties.

41. Pin the ties to the front band, aligning the raw edges. The top of the tie (straight edge) should sit right up to the seam with the bodice. This leaves 1 cm (½ in) of band extending out. Machine tack in place at 1 cm (½ in). **E**

JOINING THE FRONT AND BACK BODICE

42. Take the back bodice and place the right sides together with the front.

Pin the side seams together from the armhole notch H (or G for the exception) to the hem, sandwiching the ties. Align the seams and edges. Pin in place and stitch. Overlock or zigzag the seams together and press towards the back. **F**

43. Align the shoulder seams, right sides together. Pin in place and stitch. Overlock or zigzag the seams together and press towards the back.

44. At the armholes, working from the wrong side, press over 7 mm (⅜ in) and then a further 8 mm (⁷⁄₁₆ in), clipping into the notch to allow the hem to sit flat. Edgestitch down.

45. Overlock or zigzag the bottom of the band. Press over the remaining seam allowance and stitch in place.

46. Take the bias strip and join the ends

right sides together (see page 147 for the Piped cushion on how to join ends). Trim down the seam allowance and press open.

47. Fold over 1 cm (½ in) along one edge of the bias strip. Press in place.

48. Pin the unfolded edge of the bias strip right sides together with the neckline, lining up the seam on the bias with one of the shoulder seams.

49. Stitch with a 1 cm (½ in) seam allowance. Trim down the seam allowance to 5 mm (¼ in). Press the seam allowance up towards the bias strip. Understitch along the bias strip. **G**

50. Tuck the bias strip inside the neckline, rolling the top edge of the neckline so that you cannot see the bias strip. Press again and pin in place. Edgestitch the bias strip down to the neckline. **H I**

51. Give the top a final press.

1950s
SALLY SAILOR BLOUSE

Sailor collars were first used in the fifties and continued to be popular into the sixties. This top has a simplified sailor collar to give it a little bit of the original style but without making you feel you are in the chorus of Fred Astaire and Ginger Rogers' *Follow the Fleet*.

I have made mine out of sandwashed silk, which is so lovely to work with. But if you are new to dressmaking, a lightweight cotton or cotton lawn would be much easier to sew.

MEASUREMENTS REQUIRED

We will use our bodice block as a starting point but we need to lengthen it. The measurements below help you to do this.

❶ Tie a ribbon around your waist and measure down to the desired finished length you would like for the sailor top. I decided to lengthen mine by 15 cm (6 in).

❷ Tie a second ribbon at this point and measure around this ribbon. This will be the hem measurement.

❸ Put on the toile of your bodice block and measure down from the centre front neckline (J) to the depth you want the v-neck to be.

See page 13 for guidance on measuring.

LEVEL: ADVANCED

DRAFTING THE PATTERN

FRONT BODICE

1. Trace off the bodice block.

2. Extend line AC, using measurement ❶ to create point L.

3. Divide your hem measurement ❷ by 4 and add 2 cm (¾ in) for ease. If this is the same or smaller than CE then simply square down from E, by measurement ❶, creating point M. Join to L, creating line LM. If the measurement is bigger see page 47.*

4. To create a curved hem and side slit, measure up 4 cm (1½ in) from M, along line IM (side seam), creating point N.

5. Then measuring 8 cm (3¼ in) from M towards the centre front along line LM, create point O. Draw a smooth convex curve from point N to O.

6. From N, on the side seam, measure up

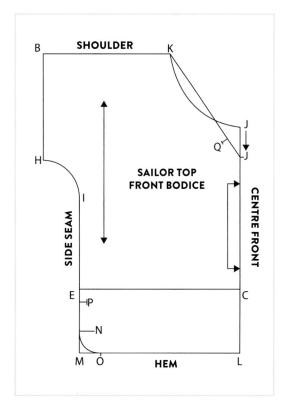

SHOULDER · B · K · SAILOR TOP FRONT BODICE · SIDE SEAM · CENTRE FRONT · H · I · J · J · Q · E · P · N · M · O · HEM · L · C

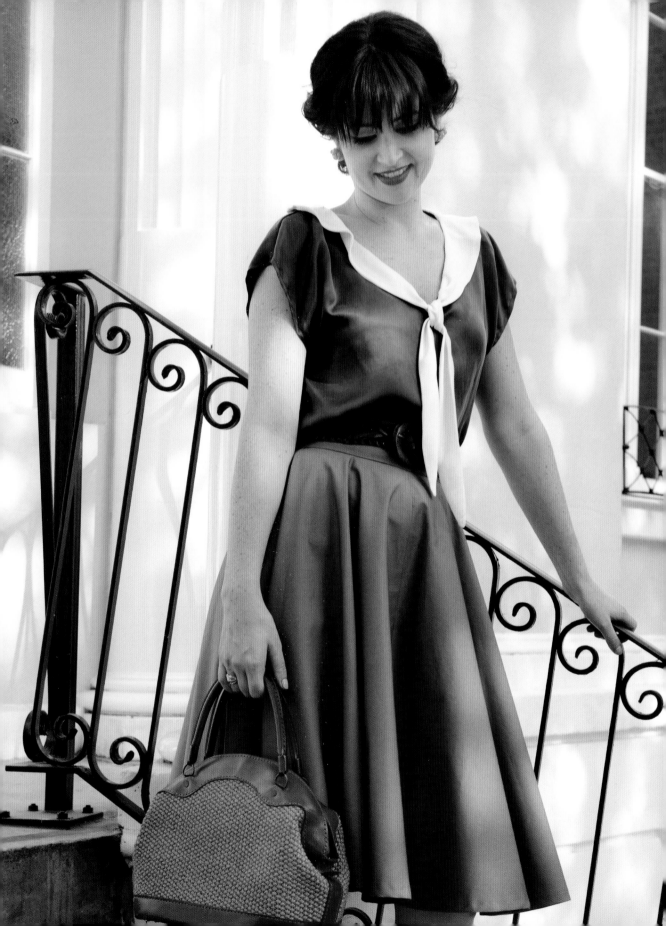

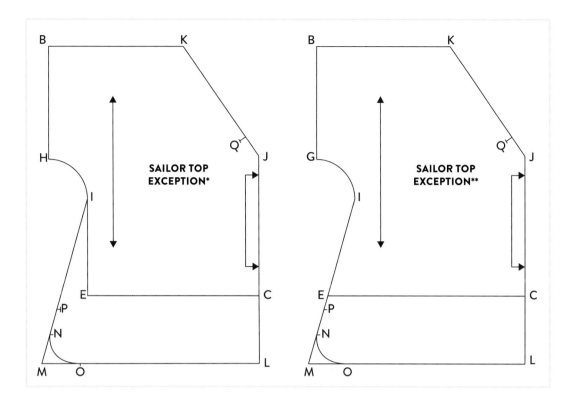

a further 5 cm (2 in) and create point P. Mark this as a notch for a side slit.

NECKLINE

7. Taking measurement ❸ square down from J to create a new J. From K to the new J draw a diagonal line, creating your v-neck.

8. Measure up 3 cm (1⅛ in) from new J, along neckline JK and create point Q. Mark this as a notch. This is where the tie will be stitched to.

TO FINISH

9. Add a 1.5 cm (⅝ in) seam allowance to all the edges (except the CF).

10. Label the bodice 'FRONT BODICE, CUT ONE ON FOLD'.

11. Copy the foldline and the grainline position from the master block.

* If your measurement stated in point 3 is bigger than CE, square across from L this distance, in a parallel line to CE. This will become line LM. From M, redraw the side seam connecting to point I.

** If your point E is wider than B, square across from L the distance in point 3, in a parallel line to CE, creating line LM. Then extend the diagonal line IE until it meets line LM. This would be a more flared shape.

BACK BODICE

12. For the back, trace off the front (the pattern you have just drafted) but without the seam allowances. At the neckline, instead of retracing the new line JK, copy the neckline from the bodice block.

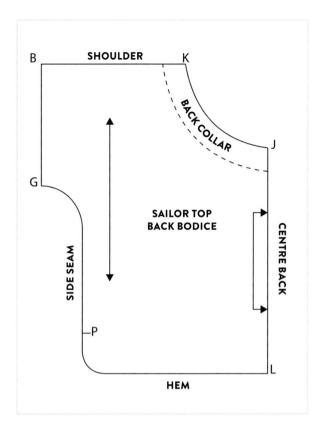

TO FINISH

13. Add a 1.5 cm (⅝ in) seam allowance to all edges except the centre back.

14. Label the bodice 'BACK BODICE, CUT ONE ON FOLD'.

15. Copy the foldline and the grainline position from the master block.

COLLAR

We will be making the collar from the bodice pattern.

FRONT

16. Starting at K, on the front neckline measure out 6 cm (2½ in) along line KB. Then measure down 8 cm (3¼ in) along the neckline KJ and at this point square out 7 cm (2¾ in). And finally at line JC measure down 6 cm (2½ in). Draw a smooth curved line joining up these points.

17. Trace off the shape onto a piece of paper with room to extend the centre front edge from J. Make sure you also trace off the notch Q from the centre front neckline.

18. To create the tie, extend the collar neckline edge (KJ) from point J by 34 cm (13½ in) to create point R.

19. Measure back along the extended line from R by 10 cm (4 in). Square down from this point by 6cm (2½ in) to create point S. Join S to the bottom of the collar that is level with J in a curved line.

20. Join R to S in a smooth curve.

21. Label KJ 'NECKLINE'.

BACK

22. Measure down 6 cm (2½ in) from the back neckline in regular intervals. Join into a smooth dashed line.

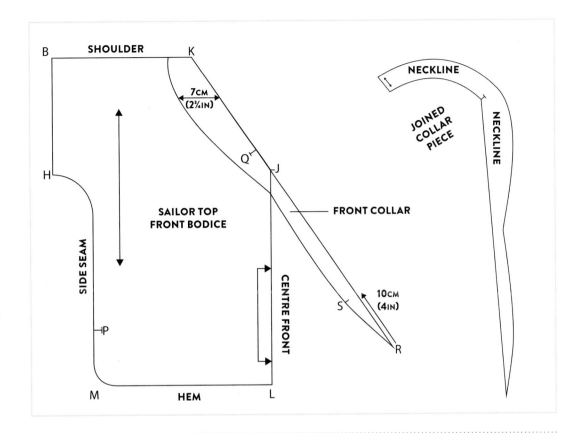

23. Trace off the shape and add 1 cm (½ in) to the shoulder seam (KB).

24. Label KJ 'NECKLINE'.

JOINING THE FRONT AND BACK COLLAR

25. Cut out both front and back collar pieces. Using the added 1 cm (½ in) on the back collar (KB) as a tab, tape the front shoulder seam to the back, creating one collar piece. Make sure you are joining the two neckline edges together. Put a notch at the join, marking the shoulder seam.

TO FINISH

26. Add 1.5 cm (⅝ in) seam allowance to all edges.

27. Label 'COLLAR, CUT TWO PAIRS'.

28. The grainline should be parallel to the centre back edge.

NECKLINE FACING

29. Trace off the front neckline KJ. Mark down 6 cm (2½ in) in regular intervals along the neckline. Join in a smooth line.

30. For the back, trace off the neckline from the back bodice and then mark down 6 cm (2½ in) in regular intervals as you did for the front. Join in a smooth line.

TO FINISH

31. Add a 1.5 cm (⅝ in) seam allowance to the shoulder seam and neckline edge on both front and back pieces.

32. Label both pieces separately 'BACK FACING' and 'FRONT FACING' respectively and then 'CUT ONE ON FOLD' for both.

33. The grainline should be parallel to

the centre back or centre front edges. Label these edges with a fold line.

CUTTING OUT

34. Cut one front bodice and one back bodice on the fold.

35. Cut one front facing and one back facing on the fold in both fabric and interfacing.

36. Using the contrasting fabric for the collar, cut two pairs.

MAKING

The seam allowance is 1.5 cm (⅝ in).

JOINING THE BODICE

37. Interface the facing pieces with a lightweight interfacing. Stay stitch the neckline of the front bodice to prevent stretching.

38. Place the front and back bodice pieces right sides together and pin the shoulder seams. Stitch together.

Overlock or zigzag the seams together. Press towards the back.

39. Pin the side seams right sides together and stitch up to the notch P. Clip into the seam allowance at the underarm curve. Overlock or zigzag the seams together. Press towards the back. **Ⓐ**

40. To make the side slits, extend the notch so that it is 2 mm (⅛ in) from the stitch line. **Ⓑ**

41. Press over 7 mm (⅜ in) and then a further 8 mm (⁷⁄₁₆ in). Pin in place and then stitch in a 'U' shape, pivoting at the corners. **Ⓒ**

MAKING THE COLLAR

42. Place one pair of collar pieces right sides together and pin the centre back edges. Stitch and press open. Then repeat with the other pair.

43. Place both collar pieces right sides together, pin in place around the outer edge and up to the notch Q on the inner edge. Stitch together. **Ⓓ**

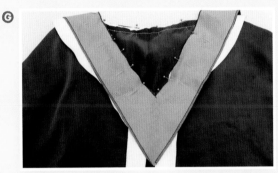

44. Trim the seam allowance to 5 mm (¼ in). Cut off the corner at the tip of the tie. Turn the right way around and press flat, keeping the seam right on the edge.

ATTACHING THE COLLAR AND FACINGS

45. Line up the inside collar edges with the right side of the neckline, ensuring the shoulder seam and notch align and the neckline notches Q. Pin in place. Machine tack with a 1 cm (½ in) seam allowance.

46. Place the front and back facing pieces right sides together at the shoulder seams. Pin in place.

47. Stitch and press open the seams. Overlock or zigzag along the bottom edge of the facing.

48. Place the facing right sides together with the bodice, sandwiching the collar. Align the shoulder seams and the neckline edges. Pin and stitch, pivoting at the v-neck. Trim the seam allowance down to 5 mm (¼ in) and clip at the curves and the v-neck. Press flat with the seam allowance towards the facing.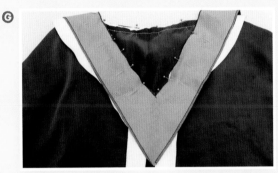

49. Understitch along the facing. Tuck the facing inside the garment and press again, this time keeping the seam on the edge.

HEMS

50. If you have an overlocker you can overlock the sleeve and bodice hems, then turn up once by 1.5 cm (⅝ in) and press to create a single hem and stitch in place. If you don't have an overlocker, create a double hem, pressing over 7 mm (⅜ in) and then 8 mm (⁷⁄₁₆ in).

51. Give a final press, being careful not to hard press over the collar and flatten the neckline.

1930s

COWL-NECK DRESS

A style taken from the thirties, cowl necks were often worn at the back of elegant evening gowns made of beautiful satins. This design is more of a day dress, and if you want you can make just the bodice and turn it into a cowl top. I have used rayon as it is light and drapey. I recommend using something similar. You will need a length of narrow elastic to fit around your waist.

MEASUREMENTS REQUIRED

Use the bodice block as a starting point but first take measurements for the skirt.

❶ Tie a ribbon around your waist and measure from this ribbon to the length you want your dress to be.

❷ Keeping the ribbon on, measure down to your widest hip point.

❸ Tie ribbon around your hip at this point ❷ and measure around the ribbon.

See page 13 for guidance on measuring.

LEVEL: ADVANCED

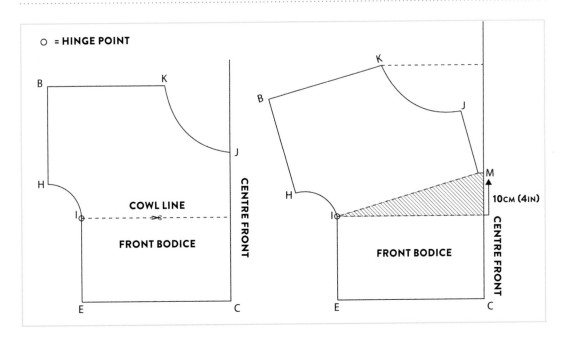

DRAFTING THE PATTERN

BACK BODICE

1. Trace off the bodice block.

FRONT BODICE

2. Trace off the bodice block and cut out.

3. Square across from just under the curve of the sleeve to the centre front (I), creating a line parallel to hem. Label this 'COWL LINE'.

4. Cut along the cowl line, leaving a hinge at the side seam.

5. On a separate piece of paper, draw a

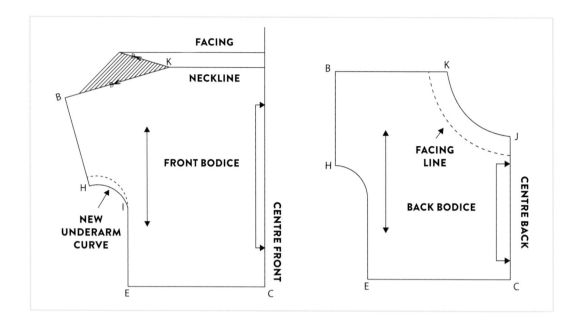

vertical line that is longer than the centre front of the bodice.

6. Position the centre front of the bodice on the vertical line. Pin the bottom half of the pattern to the paper.

7. At the point where the cowl line on the bodice meets the vertical line, label L.

8. From L, measure up 10 cm (4 in) along the line, and square across at this point on to the piece of paper, moving your bodice pattern out the way. Label this line M.

9. Pivot the top section of the bodice (keeping the hinge together) until L meets line M. Tape in place.

10. From the vertical line you drew in step 5, square across until you meet K. This is your new neckline.

11. Trace around the hem, side seam, the centre front, the new neckline, armhole and shoulder seam.

12. The front underarm curve will be a different shape to the back. To correct this, lay the back bodice on the front bodice, matching the bottom corners of the armholes (H). Trace off the back underarm curve onto the front bodice.

GROWN-ON FACING

13. Draw a parallel line 6 cm (2½ in) above the front bodice neckline, extending as wide as the whole pattern. This is the edge of the facing.

14. Fold the paper along the neckline, so the facing line is sitting behind the bodice. Working from the facing side, trace off the shoulder seam. Unfold and cut out this section (shaded in diagram). This is the grown-on facing.

TO FINISH

15. Add a 1.5 cm (⅝ in) seam allowance to all front bodice edges except the facing edge and the centre front.

16. Add a 1.5 cm (⅝ in) seam allowance to the back bodice to all edges except the centre back.

17. Label the front 'FRONT BODICE, CUT ONE ON THE FOLD'.

18. Label the back 'BACK BODICE, CUT ONE ON THE FOLD'.

19. Copy the foldline and the grainline positions from the bodice block.

BACK NECK FACING

20. On the back bodice, measure down from the neckline, 6 cm (2½ in) in regular intervals. Join in a smooth dashed line.

21. Trace off the shape and add a seam allowance to the neckline and the shoulder seam.

TO FINISH

This will create your back neck facing.

22. Label 'BACK NECK FACING, CUT ONE ON THE FOLD'.

23. The grainline should be parallel to the centre back. Add a foldline along this edge.

SKIRT

24. Draw a vertical line, longer than the desired length of your skirt. Label the top of the line A and the bottom B.

25. Square across from A the same distance as the hem of the bodice (the top of the skirt must be the same width as the hem on the bodice). Label this AC.

26. Measuring down from A along line AB, mark measurement ❷. Label this D.

27. Take measurement ❸ and divide by 4 and add 2 cm (¾ in) for seam allowance. Square across from D to this measurement, and label E.

28. From B, square across the same distance as line AC plus 4 cm (1½ in), creating point F and line BF. This

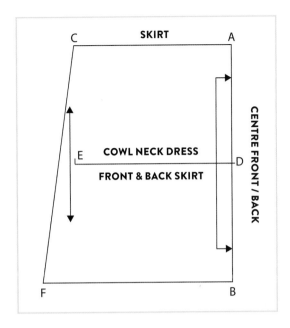

determines the flare of the skirt. If you want extra flare then add more than 4 cm (1½ in).

29. Join F to C in a straight line. The line must sit outside of point E. If it doesn't then extend line BF until it does.

TO FINISH

30. Add a 1.5 cm (⅝ in) seam allowance to all edges except line AB.

31. Label 'FRONT AND BACK SKIRT, CUT TWO ON FOLD'.

32. The grainline should be parallel to line AB. Also mark a foldline to this edge.

CUTTING OUT

33. Front bodice – cut one on fold.

34. Back bodice – cut one on fold.

35. Back neck facing – cut one on fold.

36. Front and back skirt – cut two on fold.

MAKING

The seam allowance is 1.5 cm (⅝ in).

SKIRT

37. Place the front and back pieces right sides together and pin along the side seams. Stitch together. Overlock or zigzag the seams together. Press towards the back.

FACINGS

38. Overlock or zigzag the long straight edge of the front neckline facing.

39. Fold the facing so it sits wrong sides together with the front bodice. Line it up with the shoulder seams and pin the seams. Machine tack in place with a 1 cm (½ in) seam allowance.

40. Take the back neck facing and overlock or zigzag around the outside edge. Then place it right sides together with the back bodice neckline. Pin and stitch in place. Clip the seam allowance along the curved edge of the neckline to allow it to lie flat when it is pressed. Press the seam allowance up towards the facing.

41. Understitch on the facing side.

42. Fold the back neck facing over the neckline seam, so it is wrong sides together with the back bodice. Press in place.

JOINING THE BODICE

43. Place the front and back bodice right sides together and pin at the shoulder seams, sandwiching the facings. Stitch in place and overlock or zigzag the seams together. Press towards the back.

44. Place the side seams right sides together. Pin and stitch in place. Clip

into the underarm curve. Overlock or zigzag the seams together. Press towards the back.

JOINING THE BODICE TO THE SKIRT AND ADDING THE ELASTIC

45. Turn the skirt the right way around and keep the bodice inside out. Slot the bodice over the skirt, right sides together, aligning the bottom of the bodice with the top of the skirt. Ensuring that the side seams align, pin in place. **D**

46. Stitch together. Overlock or zigzag the seams. Press up towards the bodice.

47. Take a piece of elastic and hold it around your waist so it is comfortably stretched. Add an extra 1 cm (½ in) for overlap and cut it to this length.

48. Divide the elastic into quarters, marking each quarter with a pin.

49. Find the centre front and centre back of the waist seam on the dress, by folding it in half, and place the side seams together. Mark with pins.

50. Starting at a side seam, pin one end of the elastic to the bodice side of the waist seam allowance. **E**

51. The four pins on the elastic should align to the side seams and centre front and back pins on the dress. You may want to put more pins in but I find it easier with fewer.

52. Stretching the elastic as you sew, stitch it using a zigzag stitch. When you finish sewing it all the way around, overlap the end by 1 cm (½ in) and stitch over to secure. The dress should now gather up at the waist when the elastic is released. **F**

HEMS

53. If you have an overlocker, overlock the sleeve and bodice hems and press up once to create a single hem and edgestitch in place. If you don't, then create a double hem, pressing over 7 mm (⅜ in) and then 8 mm (⁷⁄₁₆ in).

54. Give your dress a final press. Don't press the front neckline as the cowl neck is meant to be soft.

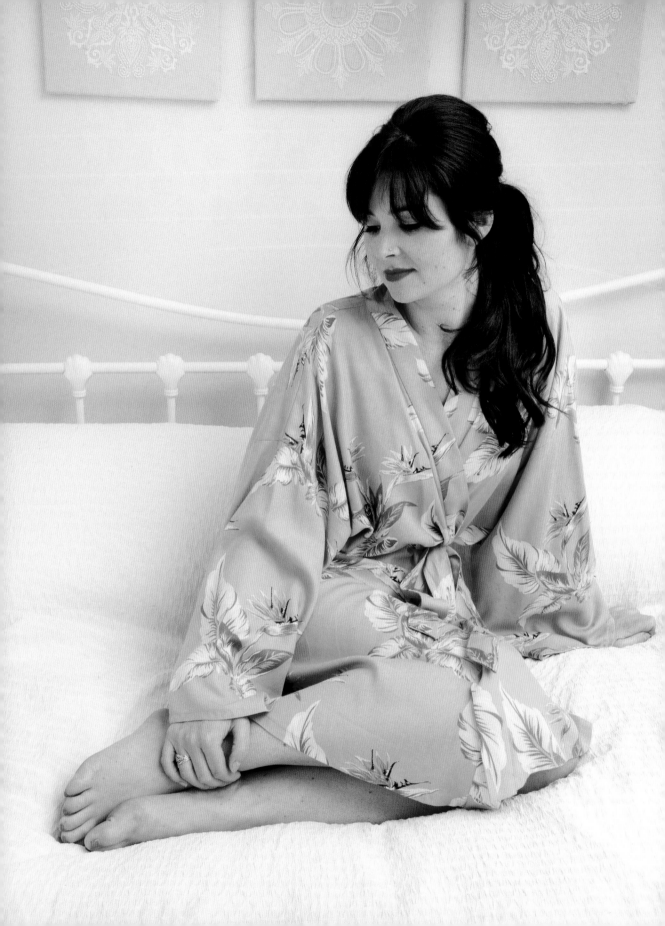

1920s
KIMONO DRESSING GOWN

With the opening up of Japan to Western trade and influences in the late nineteenth century, the craze for all things Japanese was adopted by artists and fashion designers in the West. In the 1920s the fashion was to wear kimono-style loose-fitting jackets. My dressing gown is a classic kimono shape. My gown is short but you can, of course, make it longer. It feels great wearing a more glamorous dressing gown for a change! I made my gown out of rayon but any fabric with drape, such as traditional silk, would work.

MEASUREMENTS REQUIRED

To get accurate measurements you will need to wear a tight t-shirt with a shoulder seam that sits in the middle of your shoulder.

❶ From the nape to the widest part of your top arm (keeping your arm straight).

❷ From the top arm (widest part) to your wrist or your desired finished length of sleeve.

❸ Shoulder seam to the fullest point on your bust.

❹ Mark 3 cm (1⅛ in) down from your nape and mark on the t-shirt with a pin. Taking a piece of string, hold one end on your shoulder seam and allow it to dip down to the pin at the nape and finish at the other shoulder seam. Trim the string at either end (at shoulder seam).

❺ Measure down from the nape the desired length of the gown.

See page 13 for guidance on measuring.

LEVEL: INTERMEDIATE

DRAFTING THE PATTERN

Make sure you start with a piece of pattern paper that is long enough to fit the entire length of the gown (or join two pieces together).

BACK GOWN

1. Starting with a vertical line that is length ❺, call this line AB. This is the centre back.

2. Square across from B to create an extended line (which will become the hem).

3. Square across from A, distance ❶, creating line AC.

4. From point A, measure down 3 cm (1⅛ in) along line AB, creating point D.

5. Take the piece of string ❹ and cut it in half. Holding one end of the string at point D, allow the other end to gently curve towards line AC. Where the end of the string meets line AC will become point E. The first 2 cm (¾ in) from D forming a right angle with AB. Now carefully draw a line along the top of the string (as close to the string as possible), following the curve.

6. From C, square down your bust point distance ❸. The line must be parallel to line AB. Mark this point. Label it F.

7. Square in from F, 3 cm (1⅛ in), towards the centre back creating point G. Square down from G, until you meet the bottom hemline, creating point H.

8. Measure down from G, 3 cm (1⅛ in) along line GH, creating point I. Join F to I in a smooth concave curve.

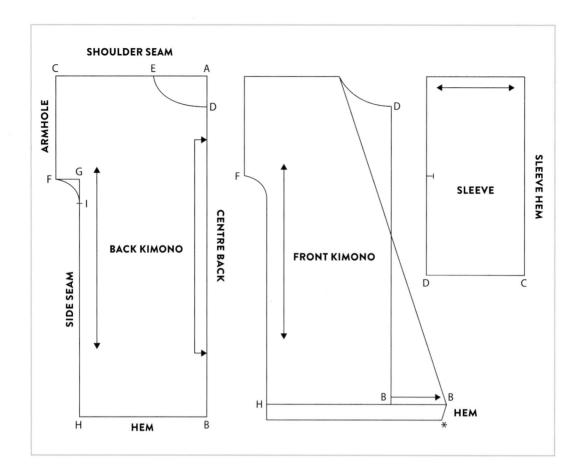

TO FINISH

9. Add a 1.5 cm (⅝ in) seam allowance to all edges except at the hem where you need to add 4 cm (1½ in), and at line AB add nothing.

10. Label 'BACK GOWN, CUT ONE ON FOLD'.

11. The grainline should be parallel with line AB. Also add a foldline to this edge.

FRONT GOWN

12. Trace off the back piece without seam allowances. You will need to have at least 20 cm (8 in) of extra paper in front of line AB.

13. Square out from B, extending the hemline by 10 cm (4 in), creating a new B. Using a metre rule, join B to E.

TO FINISH

14. Add a seam allowance of 1.5 cm (⅝ in) to all edges except at the hem where you need to add 4 cm (1½ in).

15. Fold under the original hemline (without the seam allowance) and trace off the centre front seam for the 4 cm (1½ in) of hem. This is to keep any extra fabric in the hem to a minimum. See * on diagram.

16. Label 'FRONT GOWN, CUT ONE PAIR'.

17. The grainline should be parallel to the original AB line.

SLEEVES

18. These will be rectangles made up of measurements ❷ and ❸.

19. Starting with a horizontal line the length of ❷, label this AB.

20. Multiply ❸ by 2 and square down this measurement, creating line BC.

21. From C square across the same distance as AB to create point D and finally square up to join with A, where you started. This will give you a rectangle.

22. Mark the centre of AD with a notch. This is to line up with the shoulder seam on the gown.

TO FINISH

23. Add 1.5 cm (⅝ in) to all edges except BC, where you need to add 4 cm (1½ in) for the hem. Label this end 'SLEEVE HEM'.

24. Label 'SLEEVE, CUT ONE PAIR'.

25. The grainline should be parallel with line AB.

TIES

26. Using a length of string, decide on the desired length of the ties, by tying the string around your waist with a bow.

27. Take this measurement and divide by 2, then add 3 cm (1⅛ in) for the seam allowance at either end. Make a strip this length which is 13 cm (5 in) wide. The grainline should go down the length of the strip. Label this 'TIES, CUT ONE PAIR'.

BELT LOOPS

28. Create a pattern piece that is a rectangle measuring 9 cm x 5 cm (3½ in x 2 in).

29. Label 'BELT LOOPS, CUT ONE PAIR'.

30. The grainline should be parallel with the longer edge.

CUTTING OUT

31. Back kimono – cut one on fold.

32. Front kimono – cut one pair.

33. Sleeve – cut two.

34. Ties – cut two.

35. Belt loops – cut two.

NECK BINDING

36. To create the binding, measure the length of the centre front edge, BE, excluding the hem and the seam allowance, at the shoulder seam. Then measure the back neckline, excluding seam allowances. Add these two measurements together. Add 3 cm (1⅛ in) to the length for the seam allowance. Cut 2 strips at this length 11 cm (4⅜ in) wide.

MAKING

The seam allowance is 1.5 cm (⅝ in).

37. Before you unpin the pattern on the back kimono, make a notch at the centre back at the neckline. This is to help you line up the neck binding.

JOINING THE FRONT AND BACK GOWN

38. Starting with the shoulder seams, place the front and back right sides together. Pin and stitch in place. Overlock or zigzag together and press towards the back. Ⓐ

JOINING THE SLEEVE TO THE GOWN

39. Lay the front and back gown flat, right sides up.

40. Place the notched sleeve edge right side down, aligning the notch to the shoulder seam of the front and back gown. Pin and stitch in place. Overlock or zigzag the edges together. Press towards the sleeve hem. Repeat with the other sleeve.

JOINING THE GOWN TOGETHER AT THE SIDE SEAMS

41. Place the front and back right sides together so that the underarm seams align, continuing into the side seams. Pin in place. Stitch together in one continuous seam. Overlock or zigzag the seams and press towards the back. **B**

HEMS

42. Overlock or zigzag the edge and then press up to create a single hem of 4 cm (1½ in). Edgestitch in place.

43. Repeat this process for the sleeves.

NECK BINDING

44. Place the two neck binding pieces together, right sides together, at one of the shorter ends. Pin and stitch together. Press the seam open.

45. Press over 1 cm (½ in) on the unstitched ends of the binding. Then press over 1cm of one of the long edges of the binding.

46. To attach the binding, start at the centre back of the kimono and align with the join in the binding, placing the unfolded edge of the binding right sides together with the neckline. Then continue around the rest of the neckline. Pin one side at a time, working down towards the hem, aligning the edges. The folded ends of the binding should sit flush with the hem of the kimono. **C**

47. Stitch in place and trim the seam allowance down to 5 mm (¼ in). Press the seam towards the binding.

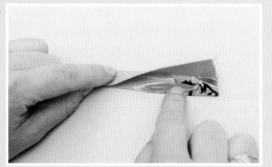

48. Fold over the folded edge so that it sits 5 mm (¼ in) over the stitch line on the inside of the kimono, hiding the seam allowance. Pin in place on the inside and then one at a time take the pins out and re-pin on the outside.

49. Using a sink stitch, work from the right side of the gown, catching the unstitched edge of the binding as you go. Slip stitch the binding ends closed. **D**

TIES AND LOOPS

50. For the tie, join the two pieces, right sides together, at one of the short ends. Press the seams open.

51. Press over 1 cm (½ in) on both long edges. Align the folded edges, wrong sides together. At the ends cut at a diagonal line to give your ties a pointed end. Press over 1 cm (½ in) on both ends. Edgestitch in place in one continuous seam, starting at a shorter end and pivoting at the corners. **E F**

52. For the belt loops, fold the wrong sides together lengthways and press to create a crease. Then press one raw edge into the central crease and then the other before folding back along the original crease line so that the folded edges meet. **G**

53. Edgestitch in place.

54. Press over 1 cm (½ in) at either end and pin in place on the side seams. They must be where your natural waist sits. You may need to put on the gown and tie it around your waist to see where is settles. Edgestitch down both ends of the belt loop. **H**

55. Give your kimono a final press. Feed the tie through the loops.

1940s
FRENCH KNICKERS

This design is based on those glamorous French knickers from the 1940s. Loose fitting, they may be a bit frilly to wear under tight clothes, but are lovely to sleep in. I have made mine out of silk satin so they feel extra special but you could use a polyester satin as long as it's lightweight. You will also need a length of narrow elastic to go around your waist, a small piece of jersey for the gusset and a lace trim.

MEASUREMENTS REQUIRED

Take a pair of knickers that fit you well and are not too low cut. Pop them on. The gusset is the part of the garment that connects the front to the back.

❶ Measure around the top of knickers. Divide this measurement by 4 and multiply by 1.2.

❷ Measure from the top centre front edge of the knickers down to the top of the gusset and add 2 cm (¾ in) for a looser fit.

❸ Then measure from the top centre back of the knickers down to the top of the gusset and add 2 cm (¾ in) for a looser fit.

❹ Take a piece of elastic and wrap it around your top hip or where the knickers come to. The elastic must be stretched but comfortable. Add 2 cm (¾ in) extra to the length and cut.

See page 13 for guidance on measuring.

LEVEL: ADVANCED

DRAFTING THE PATTERN

FRONT

1. Draw a horizontal line that is the same length as measurement ❶. Label this line AB.

2. Square down from A the front length of your knickers ❷, creating line AC.

3. Square across from C by 2.5 cm (1 in), creating line CD.

4. Decide on the desired length of the side seam. This must be 10 cm–15 cm (4 in–6 in) and shorter than AC. Square down from B the length of the side seam, creating line BE.

5. Join D to E in a diagonal line, creating line DE.

6. Measure across line AB and divide into 3 equal sections, marking these

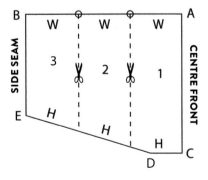

○ = HINGE POINT

points. Square down at these points in dashed lines to meet line DE.

7. Label these panels 1, 2 and 3 and mark W for waist and H for hem on each panel.

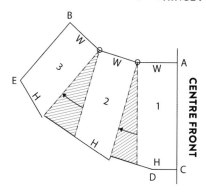
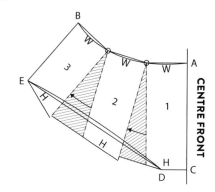

8. Cut out the pattern, then cut up the dashed lines from the hem to the waist, leaving 2 mm (⅛ in) as a hinge.

9. Take a second piece of paper and draw a vertical line, long enough to fit AC. Tape AC to this line (panel 1).

10. From the bottom left-hand corner of panel 1, measure out 2.5 cm–3.5 cm (1 in–1½ in) (depending on the desired flare of your knickers), keeping in line with the hem of panel 1. Then join this point to the top left-hand corner of panel 1 in a diagonal line. Tape panel 2 to this line.

11. Repeat the same process with panels 2 and 3. Finish by taping the remaining edge of panel 3 down. This will create a more flared knicker shape.

12. Draw a straight line from D to E. Don't worry that this will cut off sections of the pattern. Then redraw this line in an arc, straying no further than 5 mm (¼ in) from the straight line.

13. Following the new curved waist the slashing has created, redraw the waistline, from A to B, smoothing out the angles at the hinge points. Ensure that where AC and AB meet there is a right angle.

14. Trace off the pattern.

TO FINISH

15. Add a 1 cm (½ in) seam allowance to all edges except the centre front edge AC and the hem.

16. Label 'FRONT KNICKERS, CUT ONE ON FOLD'.

17. The grainline should be parallel with the centre front edge AC. Mark a foldline to this edge.

BACK

18. Take another piece of pattern paper and draw a vertical line. Place the centre front of the front knickers along this line. Trace off the waist, the centre front and the side seams only, without seam allowance.

19. Taking the back knickers measurement from ❸, lengthen AC accordingly.

20. Square across from C by 3 cm (1⅛ in) to create CD. (The back of the gusset is wider than the front.)

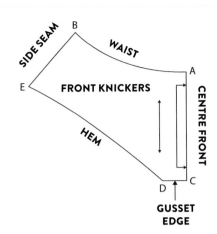

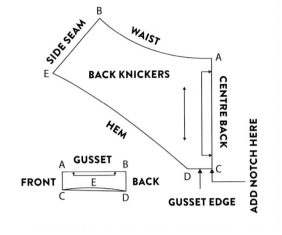

21. Join D to E in a straight line as you did in step 12 for the front. Then redraw in an arc, this time straying no more than 1 cm (½ in) from the straight line.

TO FINISH

22. Add a 1 cm (½ in) seam allowance to all edges except the centre back edge AC and the hem. When cutting out, put a notch at the bottom of the centre back edge.

23. Label 'BACK KNICKERS, CUT ONE ON FOLD'.

24. The grainline should be parallel with the centre back edge. Mark a foldline to this edge.

GUSSET

25. Take another piece of paper and draw a horizontal line measuring 10 cm (4 in), creating line AB.

26. From A, square down 2.5 cm (1 in) to C. From B, square down 3 cm (1⅛ in) to D.

27. Connect C and D to make line CD. Find the centre of CD. Mark up 5 mm (¼ in) at this point, creating E. Then draw a soft arc, starting at C, meeting E and coming back to D.

TO FINISH

28. Add a seam allowance of 1 cm (½ in) to all edges except AB, which is a foldline.

29. Label 'GUSSET, CUT ONE IN FABRIC AND ONE IN JERSEY ON FOLD'.

30. The grainline should be parallel to the line AB. Also mark a foldline to the AB.

31. When cutting out the fabric, make a notch in the wider end (BD) in the centre so it is easy to distinguish the back of the gusset.

CUTTING OUT

32. Front knickers – cut one on fold in fabric.

33. Back knickers – cut one on fold in fabric.

34. Gusset – cut one on fold in fabric and in jersey.

MAKING

The seam allowance is 1 cm (½ in).

ATTACHING THE GUSSET

35. Take the front knicker piece and

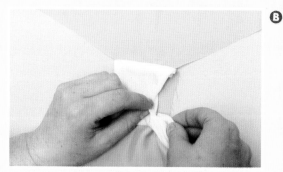

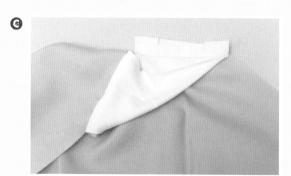

sandwich it with the two gusset pieces (one satin and one jersey). Line the un-notched shorter edges of the gusset to the bottom edge of the knickers. The satin gusset should be right sides together with the knickers. The jersey gusset should be right sides together with the wrong side of the knickers. Pin and stitch in place. **A**

36. Repeat this process with the back knickers and the notched edges of the gusset pieces. This will look like it is twisting. **B** **C**

37. Turn through so the gusset and knickers are flat. Press the seams. **D**

JOINING THE FRONT AND BACK

38. Place the front and back knickers right sides together at the side seams. Pin and stitch in place. Overlock or zigzag the edges together. Press towards the back. **E**

39. Overlock or zigzag the top edge. Fold over 1 cm (½ in) along the top edge of the knickers and press flat.

ADDING THE ELASTIC

40. Overlap the ends by 1 cm (½ in) and stitch together on the machine using a straight stitch. You will need to go over it a few times to reinforce it.

41. Divide the elastic into four, marking each quarter with a pin.

42. Find the centre front and centre back of the knickers waist, by folding them in half, placing the side seams together. Mark with pins. **F**

43. Then pin the elastic to the waist, lining the 4 pins in the elastic to the side seams and centre front and back pins on the knickers. You may want to put more pins in but I find it easier with fewer. The elastic should sit just

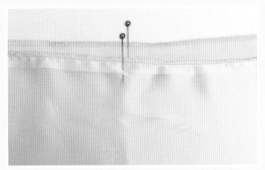

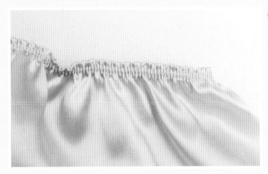

in from the top folded edge on the inside of the knickers.

44. Stretching the elastic, stitch it to the waist using a zigzag stitch. **G**

45. When you finish sewing it all the way round, the knickers should gather up at the waist when the elastic is released. **H**

HEM

46. For the hem, overlock or zigzag the edge. Then take a narrow piece of lace and starting from the back gusset edge, pin the lace to the edge, overlapping the ends. **I**

47. Zigzag stitch in place and repeat on the other side.

48. Alternatively, you can use an overlocker and stitch a rolled hem all the way round. **J**

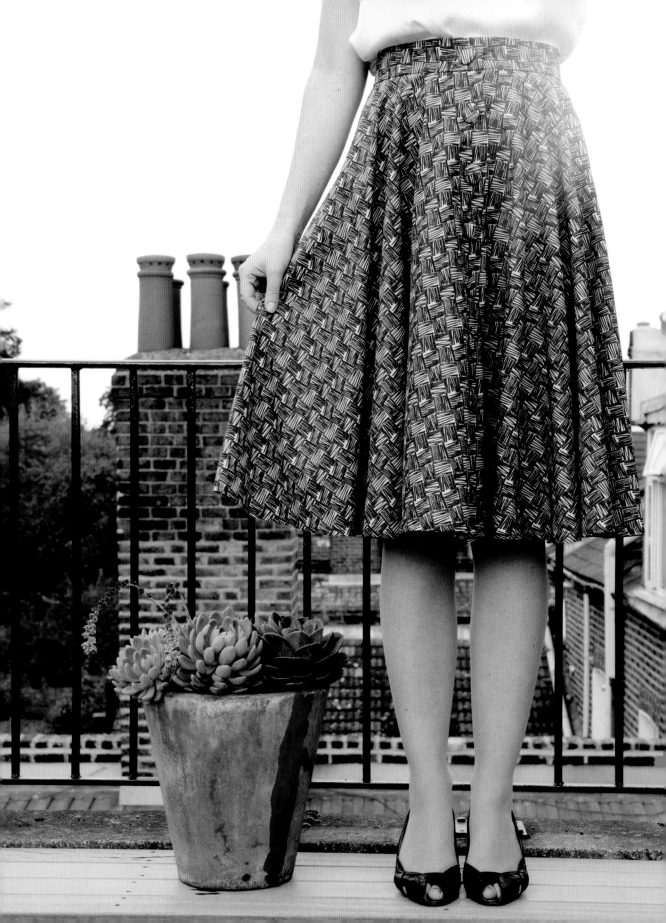

1950s

BUTTON-UP SKIRT

This skirt is based on the classic full-circle skirts of the 1950s – designed to give you the nipped-in waist that was first introduced by Dior's New Look. The skirt can be made out of light- or medium-weight woven fabrics such as cotton and wool.

MEASUREMENTS REQUIRED

❶ Tie a ribbon around your waist so it settles in the right place. Measure around your waist at this point.

❷ From the ribbon, measure the length you would like the skirt to be.

See page 13 for guidance on measuring.

LEVEL: INTERMEDIATE

DRAFTING THE PATTERN

BACK SKIRT

1. Take measurement ❶ and divide by π (Pi 3.14) and then divide by 2. This gives you the radius of your waist.

2. Draw a right angle on a large piece of paper. Label the corner A.

3. From A, measure across the horizontal line using your radius measurement in step 1 and label this B. Do the same on the vertical line, labelling it C.

4. At regular intervals, in the space in between B and C, mark this measurement, creating a smooth curve. Join these points in a curved line. Label this 'WAIST'.

5. Then from points B and C, extend the line so that it measures the length of the skirt ❷, creating points D and E.

6. From waist BC, measure at regular intervals between D and E, using measurement ❷, creating a smooth curve, as done in step 4. Label 'HEM'.

7. Add 1.5 cm (⅝ in) to line CE and label this 'CENTRE BACK'.

FRONT SKIRT

8. Trace off around B, C, D and E on a new piece of paper, excluding the seam allowance and extension at line CE. Label line CE 'CENTRE FRONT'.

9. Add 8 cm (3¼ in) to line CE. Extend the waist and hemlines in a straight line to meet this new line. This creates your button overlap.

10. Measure out from C, 2 cm (1 in) and mark with a notch F.

TO FINISH

On both front and back skirts.

11. Add a 1.5 cm (⅝ in) seam allowance to BD. Label this edge 'SIDE SEAM'.

12. Add a 1 cm (½ in) seam allowance to the hem.

13. Add a 1.5 cm (⅝ in) seam allowance to the waist.

14. Label the pattern 'FRONT AND BACK SKIRT, CUT TWO PAIRS'.

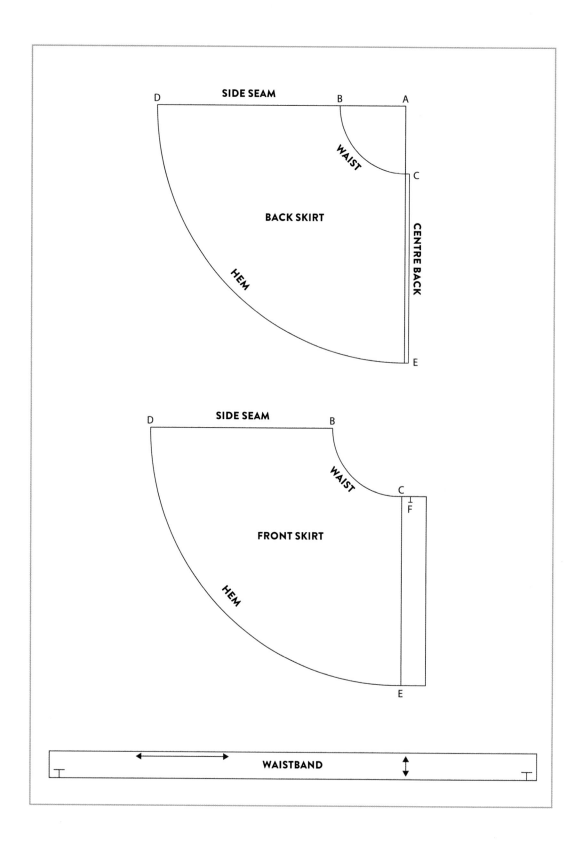

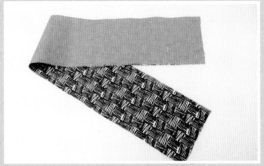

15. The grainline should be parallel to the centre front and back.

WAISTBAND

16. Taking measurement ❶ add 7 cm (2¾ in) and draw a horizontal line that length. Then square down 12 cm (4¾ in) at either end and join with parallel lines, creating a waistband strip.

17. Put a notch at 1.5 cm (⅝ in) from both ends.

18. The grainline can be parallel to the shorter or longer ends but remember to consider directional printed fabric.

CUTTING OUT

19. Front skirt – cut one pair.

20. Back skirt – cut one pair.

21. Waistband – cut one in fabric and one in interfacing.

22. Cut two extra strips of interfacing 6 cm (2½ in) wide as long as the skirt length.

MAKING

The seam allowance is 1.5 cm (⅝ in)

INTERFACING

23. Interface the waistband.

24. Iron the strip of interfacing to the centre front edges of the skirt. **B**

JOINING THE SKIRT PIECES

25. Keeping the back pieces right sides together, pin along the centre back edge and stitch together. Overlock or zigzag the seams together. Press the seams to one side. **C**

26. Lay the back right side up on the table and then place the front pieces

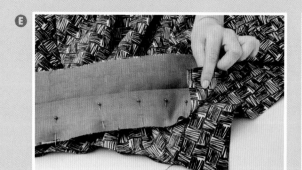

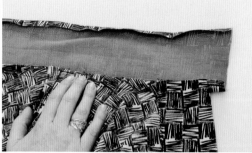

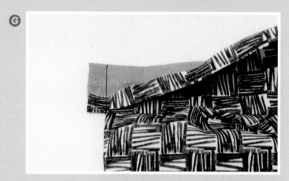

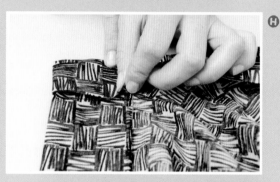

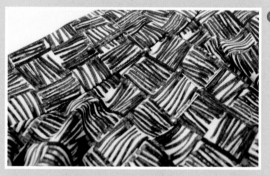

right sides down on top, aligning the side seams. Pin and stitch together. Overlock or zigzag the seams together. Press the seams towards the back.

27. Overlock or zigzag the centre front edges separately. Fold over 6 cm (2½ in) on both centre front edges, wrong sides together, using notch F as a guide. This will be in line with the edge of the interfacing and press flat.

ATTACHING THE WAISTBAND

28. Fold the waistband in half and at the fold make a notch to mark the centre back.

29. Then fold the centre back notch to the ends of the waistband to find the side seams – mark with further notches.

30. Fold the waistband in half along the length wrong sides together and press the fold flat.

31. Pin the notched edge of the waistband to the skirt, right sides together, aligning the seams on the skirt to the notches. The front edges of the skirt should match with the 1.5 cm (⅝ in) notches at the end of the waistband. Stitch in place and press the seam up towards the waistband. **E**

32. Fold over 1 cm (½ in) of the unstitched edge and press flat. **F**

33. To finish the ends, fold the waistband right sides together, aligning the folded edges of the unstitched waistband edge with the waist seam. Stitch closed with a 1.5 cm (⅝ in) seam allowance. **G**

34. Trim down to 5 mm (¼ in) and clip the corner and turn through. Press flat.

35. To finish the waistband, fold over the unstitched, folded edge – it should sit 5 mm (¼ in) over the seam line (waistband and skirt seam). Pin in place from the inside and then take the pins out, one at a time, and put them on the outside of the waistband (as you will be sewing from this side). **H**

36. From the right side of the skirt, sink stitch, catching the waistband on the inside of the skirt.

HEM

37. Overlock or zigzag the hem all the way round. Press up by 1 cm (½ in) and edgestitch in place. **I**

BUTTONHOLES

38. The waistband is secured by a button. Stitch the buttonhole horizontally, starting 2 cm (¾ in) from the end of the waistband.

39. The other buttonholes are stitched vertically, 2 cm (¾ in) from the folded edge. I have spaced mine 7 cm (2¾ in) apart. Mark the position with tailor's chalk. **J**

40. Once you have stitched your buttonholes, pin the front edges together creating a 4 cm (1½ in) overlap and mark where the buttons should go. Sew on your buttons. I used covered buttons in a matching fabric.

41. Give the skirt a final press.

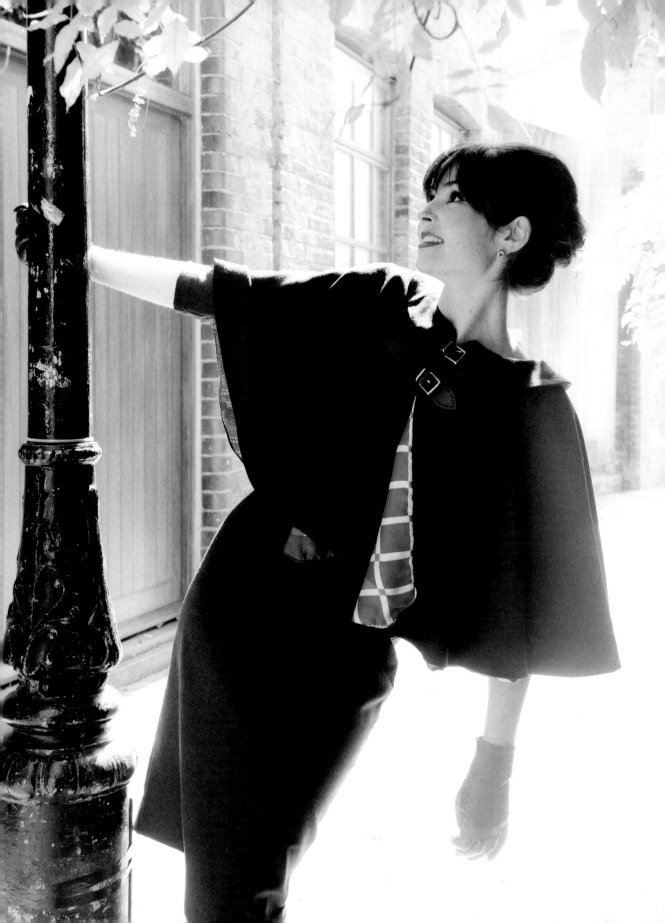

1950s
CAPELET

This design is based on a 1950s capelet I found in a vintage shop. It is perfect for warm spring or autumn days. This version is made with medium-weight wool and vintage scarves as the lining, but you could easily make a version in a lighter weight fabric for summer, using a plain silk to line it. To fasten the capelet, you can use buckles or ribbon.

MEASUREMENTS REQUIRED

❶ Measure around the base of your neck using a piece of string. Measure this string.

❷ Measure from the base of your neck to just below your elbow (with your arm straight).

See page 13 for guidance on measuring.

LEVEL: ADVANCED

DRAFTING THE PATTERN

BACK

1. Take measurement ❶ and divide by π (Pi 3.14) and then divide by 2. This gives you the radius of your neck.

2. Draw a right angle on a large piece of paper. Label the corner A.

3. From A, measure across the horizontal line the radius of your neck and label this B. Do the same on the vertical line, labelling it C.

4. At regular intervals, in the space in between B and C, mark this measurement, creating a smooth curve. Join these points in a curved line. This is your neckline.

5. From points B and C, measure out the length of the capelet, ❷, creating points D and E.

6. From neckline BC, measure at regular intervals using measurement ❷, creating a smooth curve, as done in step 4. This is your hem.

TO FINISH

7. Add a 1.5 cm (⅝ in) seam allowance to all sides except line CE, which is cut on the fold.

8. Label 'BACK CAPELET, CUT ONE ON FOLD IN FABRIC AND LINING'.

9. Label line BD 'SIDE SEAM' and CE 'CENTRE BACK'.

10. The grainline should be parallel to the centre back. Mark a foldline on this edge.

FRONT

11. Trace off the back, without the seam allowances.

12. Line CE becomes the centre front. Measure up 10 cm (4 in) from E and label point F.

13. Measure along the hemline 10 cm (4 in) and label point G. Draw a smooth convex curve between points F and G to create the curved bottom edge.

14. Mark a notch 1 cm (½ in) in from C, along line CB, and label it H.

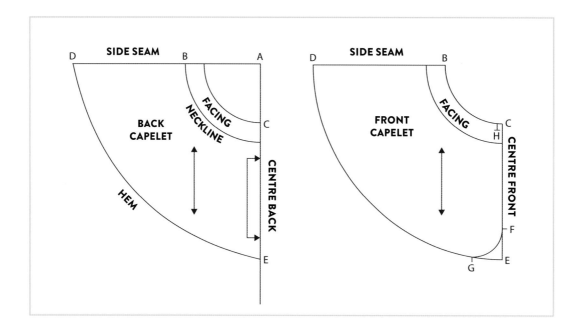

TO FINISH

15. Add a 1.5 cm (⅝ in) seam allowance to all edges.

16. Label the centre front, hem, neckline and side seams as you have done with the back piece.

17. Label 'FRONT CAPELET, CUT ONE PAIR IN FABRIC AND LINING'.

18. The grainline should be parallel to the centre front.

FACINGS

19. Measure down 7 cm (2¾ in) along the front neckline (not including the seam allowance) in regular intervals, creating a parallel curve. Join the points in a smooth curved line.

20. Trace this section off for your front facing and add a 1.5 cm (⅝ in) seam allowance to all edges.

21. Repeat the process for the back but do not add a seam allowance to the centre

back edge as this is cut on the fold.

TO FINISH

22. Label 'FRONT FACING, CUT ONE PAIR' and 'BACK FACING, CUT ONE ON FOLD'.

23. Grainlines should be parallel to the centre front and centre back. Mark a foldline to the centre back edge of the back facing.

COLLAR

24. Trace off the same shape as used for the front facing but stop at notch H. Square down from here in a parallel line to the centre front edge.

25. Along the bottom curve, measure back 3 cm (11/8 in) and mark point I.

26. Then measure up 2 cm (¾ in) along line CE and mark point J. Join I to J in a smooth convex curve. Add a 1 cm (½ in) seam allowance to the side seam.

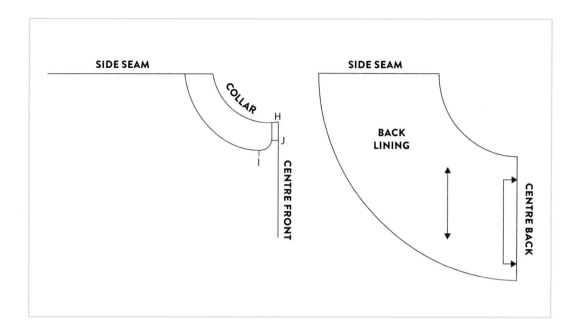

27. Trace off the back facing shape.

28. Cut out both the front and back collar pieces.

29. To join the front and back collar pieces, tape the back collar to the front collar at the side seam, using the 1 cm (½ in) seam allowance as a tab. Add a notch on the join to mark the shoulder seam.

30. Add a 1.5 cm (⅝ in) seam allowance to all edges.

TO FINISH

31. Label 'CAPELET COLLAR, CUT TWO PAIRS'.

32. The grainline should be parallel to the centre back.

CUTTING OUT

33. Front capelet – cut one pair.

34. Back capelet – cut one on fold.

35. Front lining – cut one pair.

36. Back lining – cut one on fold (or cut one pair (step 43)).

37. Front facing – cut one pair.

38. Back facing – cut one on fold.

39. Collar – cut two pairs.

LINING

40. Trace off the section below the facing line without the seam allowances, on both the front and back pieces.

41. Add a 1.5 cm (⅝ in) seam allowance to all edges.

42. Label the pieces as you did for the front and back pattern.

43. If you can't find a vintage scarf big enough for the back piece, then add a 1.5 cm (⅝ in) seam allowance to the centre back edge so that you can cut two pieces and join them together.

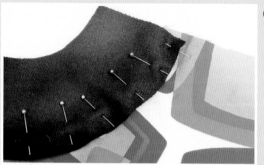

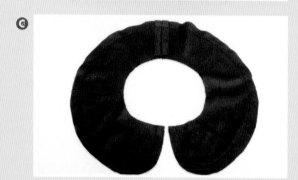

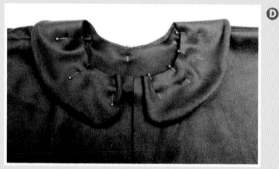

MAKING

The seam allowance is 1.5 cm (⅝ in)

JOINING THE FRONT AND BACK PIECES

44. Place the front and back pieces right sides together at the side seams. Pin and stitch in place. Press the seams open.

45. Repeat this process for the lining.

JOINING AND ATTACHING THE FACING

46. Place the front and back facing pieces right sides together at the side seams. Pin and stitch in place. Press the seams open.

47. Place the bottom edge of the facing right sides together with the top edge of the lining. This will seem awkward as they curve in opposite directions. Pin thoroughly to help ease them together. Stitch in place and clip along the entire seam to allow it to sit flat.

Press the seam down towards the lining.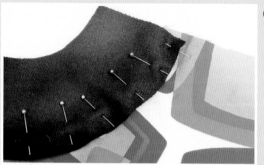

COLLAR

48. Take one pair of collar pieces and place them right sides together. Join them at the centre back. Press the seam open. Repeat with the second pair.

49. Place the joined collar pieces right sides together. Pin along the outer curve and centre front edges and stitch in place.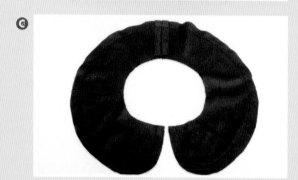

50. Trim the seam allowance to 5 mm (¼ in) and clip. Turn the collar the right way round. Press flat with the top collar slightly rolling over the edge so that you don't see the under collar.

51. Place the collar on the right side neckline of the capelet. Line up the notches with the shoulder seams. The front of the collar edge should align

with notch H on the capelet neckline. Machine tack in place using a 1 cm (½ in) seam allowance. **D**

JOINING THE LINING TO THE CAPELET

52. Place the facing (now attached to the lining) right sides together with the capelet, sandwiching the collar. Pin in place. Then pin the rest of the capelet together, aligning the centre front corners. At the centre back bottom edge, leave a 15 cm (6 in) gap to allow you to turn the cape back through. Then stitch all the way round. Trim the corners at the centre front. Trim the collar, capelet and facing seam allowances in steps around the neckline to avoid bulk. Turn the right way round. **E**

53. Press with the outer fabric slightly rolling over the edge so that the lining doesn't show. Press the seam allowances of the gap so that they line up with the stitched edges either side. Pin in place and topstitch all the way round the capelet about 2 mm (⅛ in) from the edge. The topstitch will close the gap along the bottom edge and will help keep the edge neat and prevent the lining from showing. **F G**

54. I have chosen to use buckles to fasten my capelet but you could use grosgrain ribbon or whatever you fancy. The buckles are sewn on by hand using a strong polyester thread, back stitching through the holes. Or if you are using ribbons, tuck the ends under so there are no raw edges. **H**

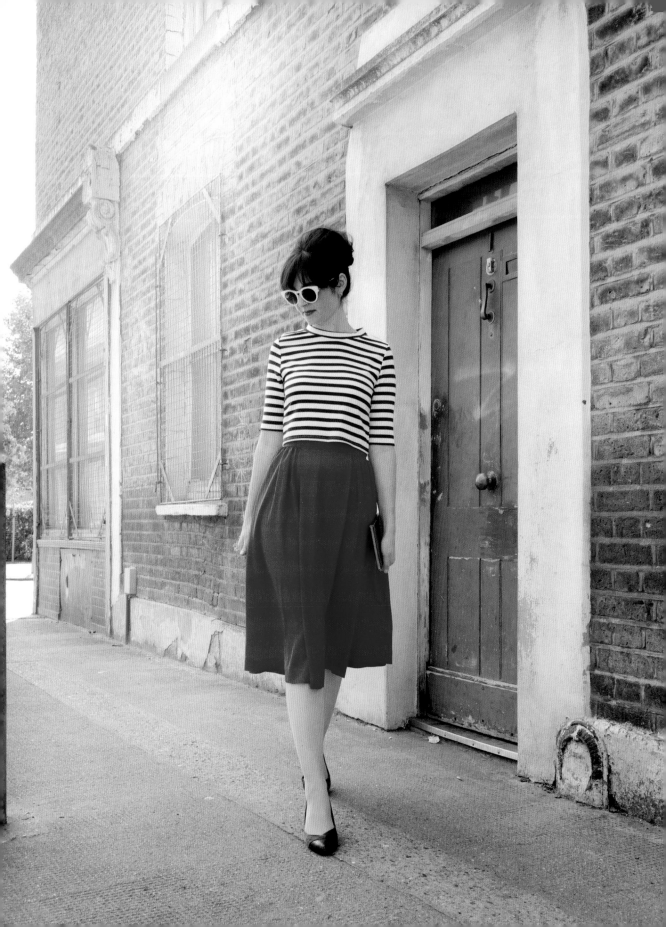

1950s
BOX-PLEAT SKIRT

This skirt is taken from Sew Over It's 1950s summer dress inspired by none other than Betty Draper from *Mad Men*. I made my skirt out of crepe for a softer look but it would also work well in cotton. You will need a 23 cm (9 in) concealed zip and a concealed zip foot and lightweight interfacing for the waistband.

MEASUREMENTS REQUIRED

❶ Tie a ribbon around your waist. Measure around this ribbon.
❷ Then measure down from this ribbon the desired length of the skirt.

See page 13 for guidance on measuring.

LEVEL: INTERMEDIATE

DRAFTING THE PATTERN

FRONT SKIRT

1. Draw a vertical line, the length of your skirt. Label it AB.

2. Taking measurement ❶, divide it by 4 and then subtract 6 cm (2½ in). Multiply this by 2 and then add 6 cm (2½ in).

3. Square across from A the measurement above to create line AC. Label 'WAIST'.

4. Square down from A, the length of the skirt ❷ to create line AB. Square across from B the same measurement as used in step 2 to create line BD. Then square up to C to create a rectangle. Label line BD 'HEM'.

5. Measure 6 cm (2½ in) from A, along line AC to create point E. Create a notch here to mark where the pleat will fold.

6. Measure from E to C and divide into 3 equal sections. Square down a dashed line from these points. Label the sections panel 1, 2 and 3.

7. Cut out the pattern. Then cut up the dashed lines from the hem to the waist, leaving 2 mm (⅛ in) as a hinge at line AC.

8. Draw a vertical line on a second piece of paper. Glue the centre front (line AB) to this line.

9. Measure out 10 cm (4 in) from the bottom left-hand corner of panel 1, and then draw a straight line up to the top left-hand corner of panel 1. You will need to use a metre rule.

10. Glue panel 2 to this line, keeping your hinge at the waist.

11. Repeat the process with panel 2, finishing by glueing down the left-hand edge of panel 3.

12. Following the new curved waist the slashing has created, redraw the waistline, from E to C, smoothing out the angles at the hinge points.

13. Redraw the hem, joining up the gaps in between the panels in a smooth curve.

14. Trace off the whole pattern onto a new piece of paper.

TO FINISH

15. Add 1.5 cm (⅝ in) to all edges. If you want to finish the hem by hand, add 4 cm (1½ in) to this edge.

16. Label 'FRONT SKIRT, CUT ONE PAIR'.

17. Label line AB 'CENTRE FRONT' and line CD 'SIDE SEAM'.

18. The grainline should be parallel to AB. Also label this 'CENTRE FRONT' and add a foldline.

BACK SKIRT

19. Trace off the front. You do not need notch E. If you want to finish the hem by hand, add 4 cm (1½ in) to this edge.

20. Label 'BACK SKIRT, CUT ONE PAIR'.

21. Label line AB 'CENTRE BACK' and line CD 'SIDE SEAM'.

22. The grainline should be parallel to the centre back.

FRONT PLEAT

23. On a separate piece of pattern paper, draw a vertical line the same length as the skirt, leaving space either side of the line. Label this line AB.

24. Square across 6 cm (2½ in) to the left of A and label point C. Square down the length of the skirt to D, creating line CD.

25. Square across 7.5 cm (3 in) to the right of A, and label point E. Square down the length of the skirt to F, creating the line EF. Join points D and F in a straight line.

26. Add notches at A and B.

TO FINISH

27. Add 1.5 cm (⅝ in) seam allowances to all sides except EF, which is cut on the fold. If you want to finish the hem by hand, add 4 cm (1½ in) to DF.

28. Label 'FRONT PLEAT, CUT ONE ON THE FOLD'.

29. The grainline should be parallel with EF. Also mark a foldline to EF.

WAISTBAND

30. Add 4 cm (1½ in) to your waist measurement ❶.

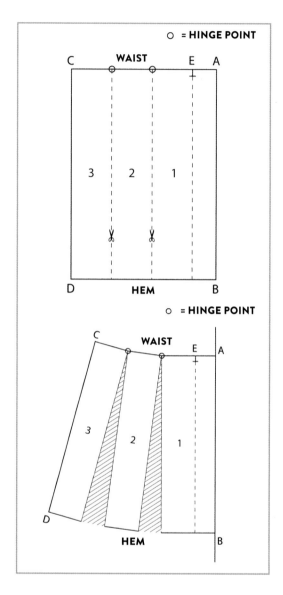

31. Draw a horizontal line to this measurement and label it AB.

32. Square down 13 cm (5 in) from either end of the line. Join these points in a parallel line to AB.

33. From the right-hand end of the waistband, measure in 3 cm (1⅛ in) along line AB and mark with a notch.

34. From the left-hand end of the waistband, measure in 1 cm (½ in) along line AB and mark with a notch.

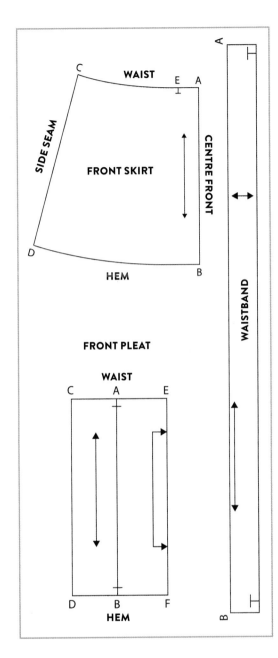

37. Front skirt – cut one pair.

38. Back skirt – cut one pair.

39. Front pleat – cut one on fold.

40. Waistband – cut one in fabric and one in interfacing.

MAKING

The seam allowance is 1.5 cm (⅝ in)

FRONT SKIRT

41. Place one of the long edges of the front pleat right sides together with the centre front of one of the skirt pieces, essentially lining CD to AB. Pin in place and stitch together. Overlock or zigzag the seams together. Press towards the side. Repeat with the other side of the pleat and the other front skirt piece. **Ⓐ**

42. Line up notches A on the pleat with notches E on the skirt, essentially folding the pleat into position. Machine tack in place. **Ⓑ**

BACK SKIRT

43. Overlock or zigzag the centre back edges separately.

44. Lay one of the back pieces right side up. Open the concealed zip and place it right side down, so that the teeth are 1.5 cm (⅝ in) from the centre back edge of the skirt. The top of the zip, where the teeth end, should sit 1.5 cm (⅝ in) from the waist of the skirt. Pin in place, with pin heads facing away from the top of the zip. **Ⓒ**

45. Attach a normal zip foot to the machine. Machine tack along the middle of the zip tape.

46. Then attach the concealed zip foot. Feed the teeth into the channel on the

TO FINISH

Seam allowances are already included.

35. Label 'WAISTBAND, CUT ONE IN FABRIC AND INTERFACING'.

36. The grainline should be perpendicular to the line AB.

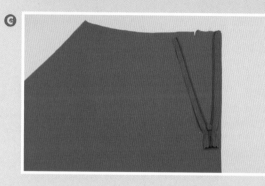

foot, peeling them back so that you are lined up to stitch in the groove. Stitch in place.

47. Repeat this process on the other side, making sure you line up the zip in the same position. **D**

48. Pin the remaining edges of the centre back together. Put the regular zip foot back on the machine and stitch up to the bottom of the zip, getting as close to the zip stitching as possible. Press the seam open.

JOINING THE FRONT AND BACK SKIRTS

49. Join the front skirt to the back skirt at the side seams. Overlock or zigzag together and press towards the back.

50. Run a gather stitch along the top edge, from notch E on both sides of the front skirt to the zip on the back skirt.

51. Gather up the top of the skirt, keeping

the side seams ungathered 1 cm (½ in) either side for a more flattering look. **E**

ADDING THE WAISTBAND

52. Iron the interfacing onto the wrong side of the waistband. Re-cut the notches.

53. Iron the waistband in half lengthways, creating a fold.

54. Find the centre front of the skirt pleat and mark with a pin.

55. Fold the waistband in half and at the fold make a notch to mark the centre back.

56. Then fold the centre back notch to the ends of the waistband to find the side seams – mark with further notches.

57. Pin the waistband right sides together with the skirt, matching the notches to the side seams and the centre front. The 1 cm (½ in) and 3 cm (1⅛ in) notches should line up with the centre

back edge of the skirt. The waistband should extend out 1 cm (½ in) and 3 cm (1⅛ in) at CB respectively. Evenly distribute the gathers and pin. Stitch in place.

58. Press the seam up towards the waistband.

59. Fold over 1 cm (½ in) of the unstitched edge and press flat.

60. To finish the 1 cm (½ in) end, fold the waistband right sides together, aligning the folded edges and stitch closed with a 1 cm (½ in) seam allowance.

61. To finish the 3 cm (1⅛ in) overlap end, fold the waistband right sides together, unfolding the edges so the raw edges meet. Working from the side you can see the stitches, continue the stitch line up to 1 cm (½ in) from the end, then pivot up to close the end.

62. Trim both ends down to 5 mm (¼ in), clip the corners and turn through. Press flat.

63. To finish the waistband, fold over the unstitched, folded edge, it should sit 5 mm (¼ in) over the seam line (waistband and skirt seam). Pin in place from the inside and then, one at a time, take the pins out and put them on the outside (as you will be sewing from this side).

64. From the right side of the skirt, use a sink stitch, catching the waistband on the inside of the skirt, or slip stitch closed by hand.

HEM

65. If hemming by machine, overlock or zigzag the edge and then press up by 1.5 cm (⅝ in) and edgestitch in place.

66. If hemming by hand, overlock or zigzag the edge and then press up by 4 cm (1½ in) and hand stitch in place.

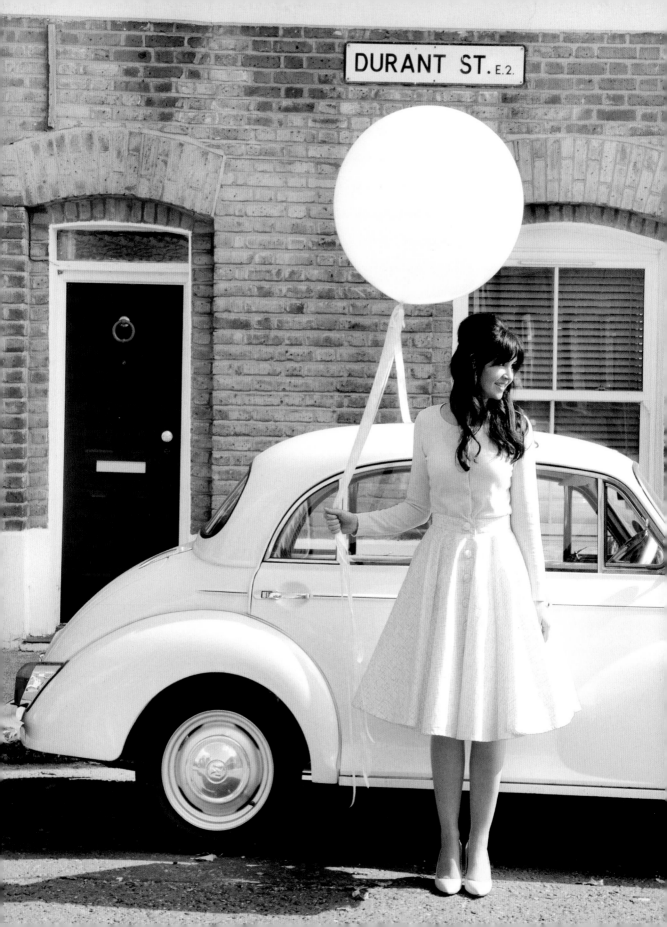

1950s
CARDIE DRESS

I often wear a cardigan with a full circle skirt, so I thought wouldn't it be nice if they were joined as one. We are using the skirt pattern from the 1950s button-up skirt project on page 71. This design works with a fine knit cardie with a narrow button placket.

LEVEL: INTERMEDIATE

MAKING

Make up the skirt as before, but don't add the buttonholes.

ATTACHING THE WAISTBAND TO THE CARDIE

1. Put a pin in 4 cm (1½ in) from the left side of the waistband of the skirt (this marks the overlap).

2. Put your cardie on. Fasten the skirt waistband to the cardie with a pin, overlapping the right-hand side until it meets the 4 cm (1½ in) pin. Make sure the cardie is lying smoothly, with the side seams of the cardie matching up with the side seams of the skirt and the right-hand edge of the waistband sitting flush with the right-hand edge of the cardie. Carefully pin the skirt waistband to the cardie all around your waist, as far as you can, up until the left-hand overlap. Pin near the top of the waistband. Then undo the buttons of the cardie and pin the left-hand edge of the waistband to the left hand side of the cardie. The edge of the cardie should sit 2 cm (¾ in) from the edge of the waistband. **A**

3. Remove the cardie dress and tack the cardie to the skirt along the pin line. You will probably need to ease the cardie into the waistband. **B**

4. Fold the bottom of the cardie up, along the bottom edge of the waistband. Press flat to create a crease and then trim 2 cm (¾ in) from the crease edge. **C**

5. Iron the crease back the other way. Tuck the raw edge under and pin the crease/ folded edge to the bottom of the waistband. Tack in place. **D**

6. From the right side of the waistband, topstitch all the way around the edge of the waistband, stitching the cardie to the skirt. **E**

BUTTONHOLES

7. Decide exactly where you would like your buttons to be positioned on the skirt. Depending on the size of the buttons, it would look best if they are spaced the same distance as they are on the cardie. Ideally they will be in line with the cardie buttons, and therefore the same distance from the

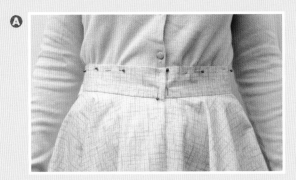

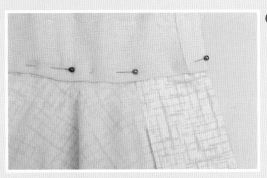

skirt edge as the buttons are from the cardie edge.

8. The buttonhole on the waistband should be stitched horizontally. If the waistband is too thick to stitch a buttonhole in, you can use a trouser hook and bar and add a button on top. The other buttonholes are stitched vertically. Mark their position with tailor's chalk. **F**

9. Once you've stitched your buttonholes, pin the front edges together with an overlap of 4 cm (2 in) and mark where the buttons should go. Sew on your buttons.

10. Give the dress a final press.

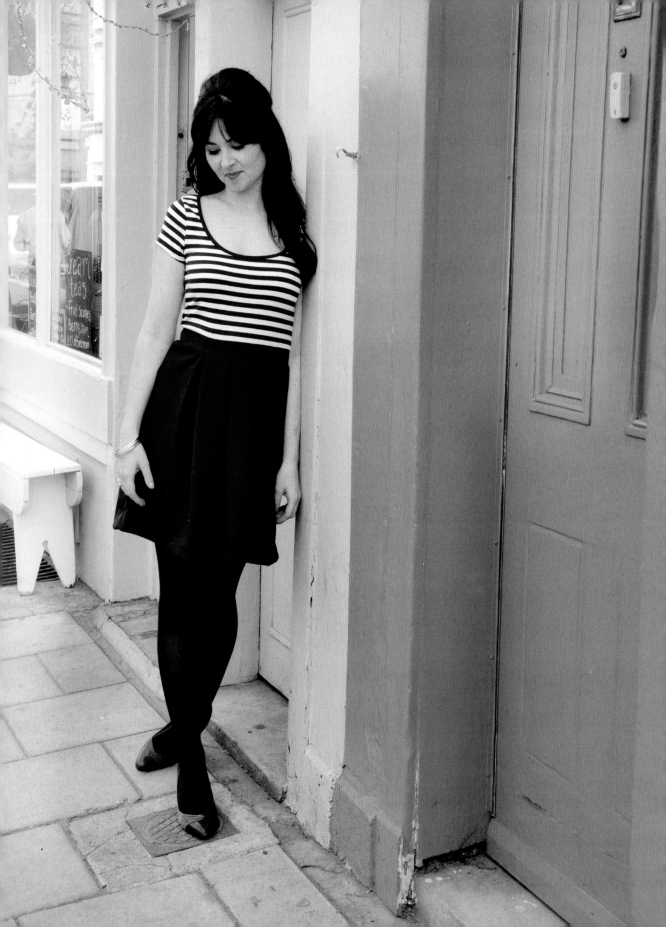

1960s
PLEATED DRESS

This dress was inspired by a little 1960s dress I have, with a fitted bodice and pleated skirt. It all starts with a jersey top and the skirt is added to that – there is no need for a zip. I used a medium-weight jersey for the waistband and skirt. You will need a jersey top that fits snugly.

MEASUREMENTS REQUIRED

❶ Tie a ribbon around your waist. Measure around this ribbon.
❷ Then measure down from this ribbon the desired length of the skirt.

See page 13 for guidance on measuring.

LEVEL: INTERMEDIATE

DRAFTING THE PATTERN

WAISTBAND

1. Take measurement ❶ and divide it by 2. Draw a horizontal line on a piece of paper this length.

2. Square down 5 cm (2 in) from one end, then square across and up to create a long rectangle.

3. Then add 1 cm (½ in) to each side.

4. Label 'WAISTBAND, CUT ONE PAIR'.

5. The grainline should be parallel to the short ends.

SKIRT

6. Draw a vertical line the length of skirt ❷. Label this AB.

7. Take measurement ❶ and divide it by 2 and add 36 cm (14¼ in) for 3 x 12 cm (4¾ in) pleats. Square off from A this distance, creating line AC.

8. Square down from C the same skirt length measurement. Label this CD. Join B to D to create a rectangle.

9. Along line AC find the centre point. Mark with a notch and label centre front. Then measure 6 cm (2½ in) either

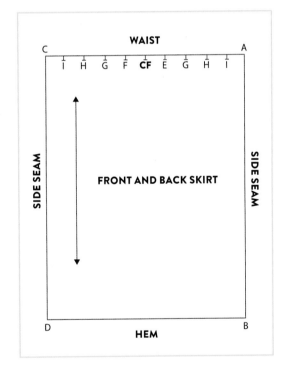

side and mark with further notches E and F. This creates one pleat.

10. I have decided to put my pleats 6 cm (2½ in) apart but you could space them out further if you want, as long as they fit within your rectangle. To mark the

next pleat, measure across 6 cm (2½ in) from notch E, with another notch labeled G. Mark another two notches at 6 cm (2½ in) and 12 cm (5 in) from G. Label these H and I respectively. Repeat this process from F. You will now have notches for three pleats.

11. Add a 1 cm (½ in) seam allowance to the side seams (AB, CD), top waist seam (AC) and to the hem (BD).

12. Label the pattern piece 'FRONT AND BACK SKIRT, CUT ONE PAIR'.

13. The grainline should be parallel to AB.

CUTTING OUT

14. Front and back skirt – cut one pair.

15. Waistband – cut one pair.

MAKING

The seam allowance is 1 cm (½ in). Put on your top. Tie a ribbon around your waist and anchor in place with a few safety pins. Remove the top and mark a straight cutting line 1 cm (½ in) below the waist ribbon using chalk and a ruler. Cut along this line.

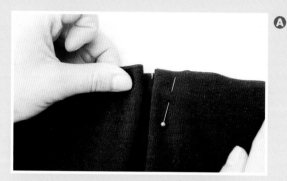

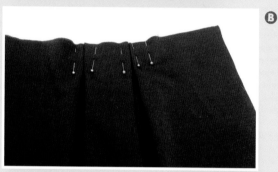

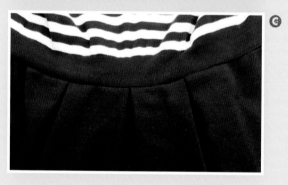

MAKING THE PLEATS

16. Working from the wrong side of the front skirt piece, find the centre front pleat. Fold in notches E and F to line up with the centre front notch. Pin in place to create a pleat. **A**

17. Repeat this process with the other two pleats, folding the side notches into the centre notch. **B**

18. Machine tack along the top to secure the pleats using a 1 cm (½ in) seam allowance.

19. Repeat this process with the skirt back.

JOINING THE SKIRT

20. Place the front and back skirt pieces right sides together. Pin the side seams and stitch in place with a 1 cm (½ in) seam allowance. Overlock or zigzag the seams together and press towards the back.

MAKING AND ADDING THE WAISTBAND

21. Place the two waistband pieces right sides together. Pin the shorter ends and stitch in place. Overlock or zigzag the seams together and press towards the front.

22. Place the waistband, right sides together, over the top of the skirt and align the edge of the waistband with the top edge of the skirt. Make sure the side seams on the waistband match the side seams on the skirt. Pin in place. Stitch together with either an overlocker or a stretch stitch on your machine. If you used the stretch stitch, then zigzag the seams together after. Press up towards the waistband. Unpick the machine tacking from step 18.

JOINING THE SKIRT TO THE TOP

23. Place the unstitched edge of the waistband right sides together with the bottom edge of your jersey top. Now match the side seams on the waistband with the side seams on the top. You may need to do a little bit of easing but there shouldn't be too much as long as your jersey top fits you snugly. Pin and stitch together with either an overlocker or a stretch stitch. If you used the stretch stitch, then zigzag the seams together. Press down towards the waistband.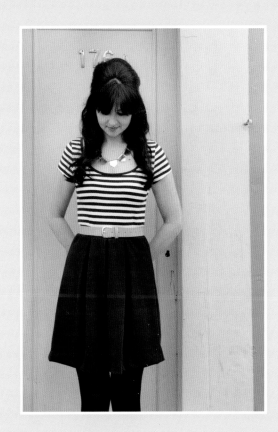

HEM

24. Overlock or zigzag the hem, being careful not to stretch it. Press up 1 cm (½ in) and edgestitch down.

A little something to go with it...

1940S *to* 1970S

FASCINATORS • CLUTCH BAGS
• HANDBAGS • MEN'S TIES •
VEILS • HATS • NECKLACES

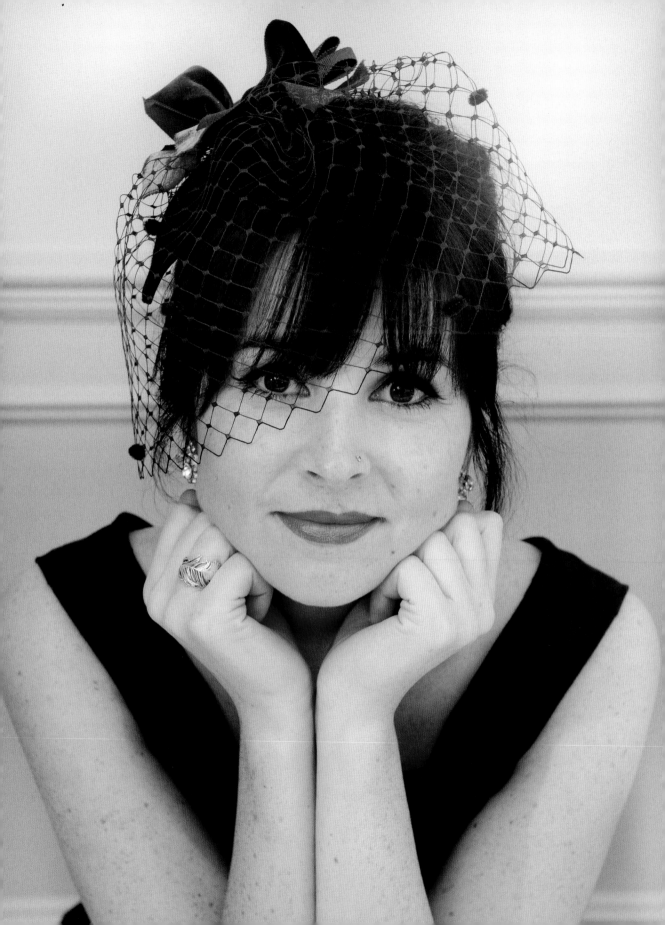

1940s
FASCINATOR

There is something that is so glamorous and so vintage about a fascinator with veiling. I am at that age when weddings dominate my summer. Making a dress that no one else has is one thing but walking in with a unique fascinator as well – that's something else.

Unlike the other projects in the book, you don't need to follow this step by step. I'm going to show you the various techniques that you can take away with you to create your own combination. The veiling must be applied first as the gathered centre needs to be hidden. Flowers, leaves and ribbons are added on top of this.

YOU WILL NEED

★ Base – mine is velvet trimmed

★ Veiling - 25 cm (10 in) x 25 cm (10 in)

★ Flowers or leaves to decorate

★ Petersham and/or velvet ribbon (Petersham is a bit like grosgrain ribbon but has a 'scalloped' edge and a bit more structure)

★ Plastic hair comb

LEVEL: EASY

VEILING

1. Starting from the factory finished edge (this will be a zigzag edge), square up 21 cm (8¼ in) and then square across the full width of the veiling. This will give you an even strip of veiling. Use the little squares as a guide to be able to cut straight.

2. Taking a needle and single thread, sew a tacking stitch across the length of the veiling, about 2 cm (¾ in) from the cut edge. Essentially, you will be weaving in and out of every square. Make sure you leave a tail of thread at the beginning and end. 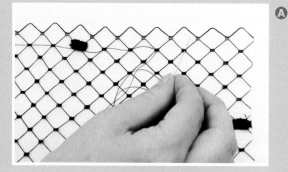 Ⓐ

3. Pull the two ends so that the veiling gathers up and tie in a knot to secure. Ⓑ

4. To attach the veiling to the fascinator, take the gathered edge of the veiling and pin it towards the back of the base. Then try on the base and adjust the

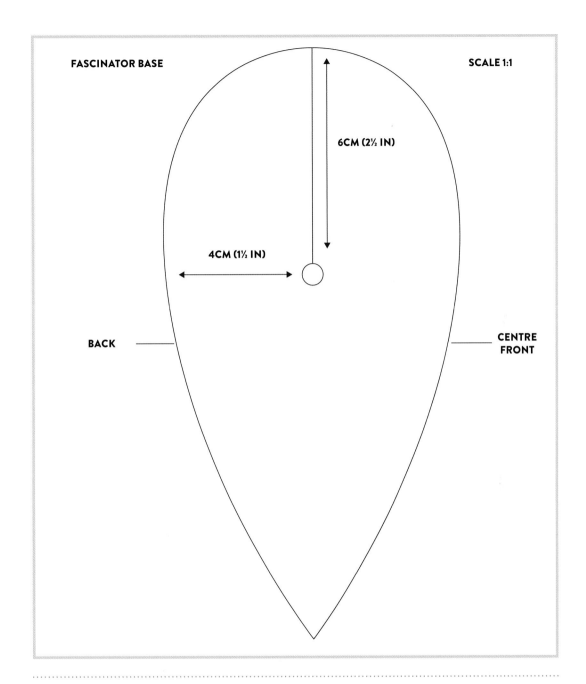

FASCINATOR BASE

SCALE 1:1

6CM (2½ IN)

4CM (1½ IN)

BACK

CENTRE
FRONT

positioning accordingly. It is useful to have a friend to help you with this. **G**

5. Ideally the veiling should end below the eye and above the nose. You don't want it sitting too close to your face as it will irritate you and can get caught in your eyelashes! If it's bouncing off your face too much, try pinning at the top and tip of the base, which can be steamed down later with an iron. For reference, mine was positioned 6 cm (2½ in) from the curved end of the base and 4 cm (1½ in) in from the back. Once you have decided on the position of the veiling, secure with a couple of extra pins.

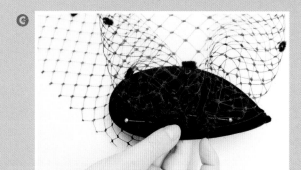

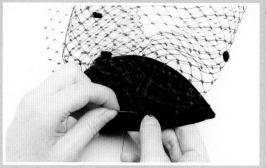

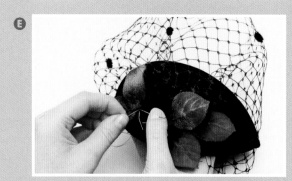

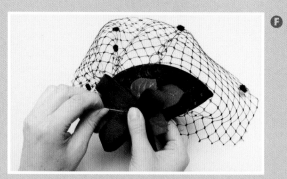

6. Taking a needle and single thread, stitch up from the underside of the base, through the gathers in the veiling, and back down again. Do enough stitches so that the gathering stays in place. Don't worry if your stitches aren't neat, as they will be covered. The same goes for the underside – no one will see this! **D**

7. Then trim the excess veiling to 1 cm (½ in).

ADORNING YOUR FASCINATOR

8. I used a combination of millinery leaves and velvet ribbon. Start by having a play around with different combinations. The ribbons need to hide the messy edge of the veiling and also add height to the fascinator.

ADDING LEAVES OR FLOWERS

9. Decide whether you want them to overlap and if you want them on just one side of the fascinator or on both.

10. The leaves and flowers should have wire stems that are malleable. If they are really long, trim them down. Make a few stitches through the base of the leaves and the flowers and then a few stitches over the wire stems to secure them. **E**

ADDING RIBBONS

11. The ribbons can be twisted and turned into loops to create detail and height. **F**

HALF BOW

12. Start with a ribbon length that is double the length of the finished bow. Cut both ends of the ribbon at a nice angle, creating a point.

13. Fold the ribbon in half so that the two points are together and there is a loop at one end, then make a pinch in the

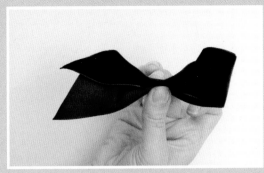

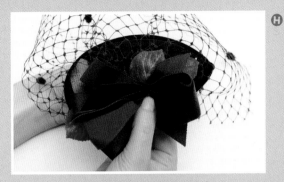

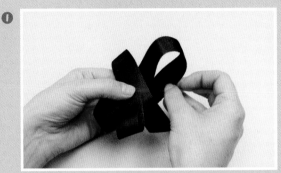

middle. This will create a half bow. Stitch to hold the bow in place. **G**

14. These are great fillers and will cover any mess. You only need a few as they are quite a statement. I used one. **H**

RIBBON TWISTS

15. Cut about 15 cm (6 in) in length (this can be cut down later) and then twist in the middle – this makes the ribbon stand to attention and can add height. Make a few of these and pin them to the base. Try the fascinator on and cut the ribbons to length. They look good bunched together. I have made entire headpieces using this simple idea and it looks really effective.

RIBBON LOOPS

16. Cut a length of ribbon, cutting a point at one end. Starting at the pointed end, form loops with the ribbon, bringing them back to a central point each time. Stitch the central point down. This makes a good base to cover the veiling stitches. **I**

ATTACHING A COMB

17. You can buy combs in lots of different sizes. If you can't find ones that are small enough, you can trim them down with pliers. Just make sure you trim evenly from both sides.

18. The comb is stitched along the velvet of the underside of the fascinator at the back, with the prongs facing towards the front. Use a double thread and stitch around the end of the comb in overstitches. Don't make the stitches too tight as you need to have a little bit of give so that you can adjust the comb in your hair. **J**

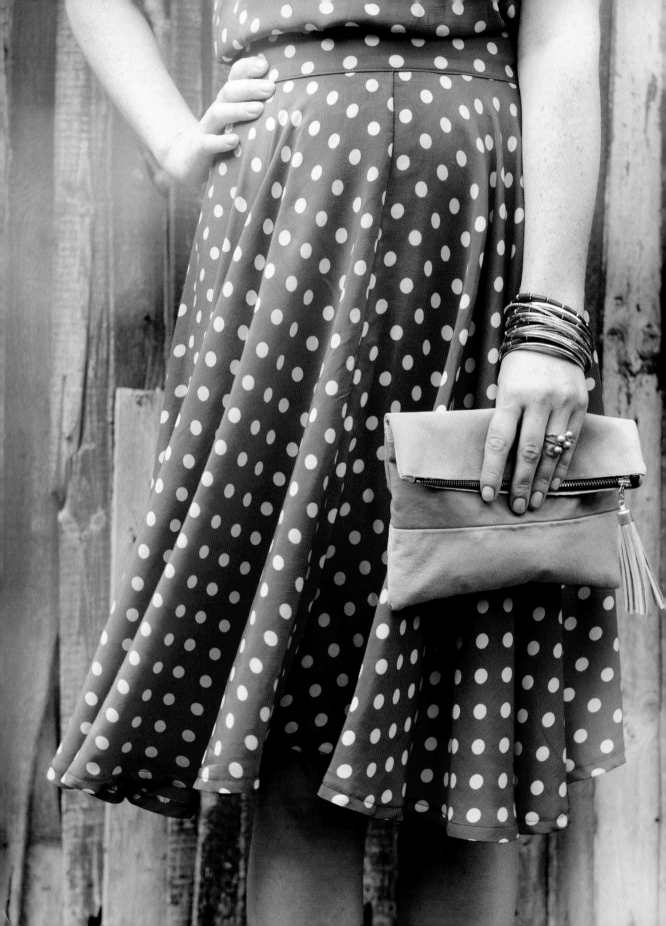

1970s
CLUTCH

This design was inspired by a clutch bag I have from the 1970s. It's made from a combination of leather and suede strips that give it contrasting textures. I have kept mine in similar colours to the original, but you could choose brighter colours for a much more modern colour-blocked bag.

YOU WILL NEED

★ A4 piece of card
★ Suede 25 cm x 40 cm (10 in x 15¾ in)
★ Leather 25 cm x 15 cm (10 in x 6 in)
★ Leather backer (medium weight) 50 cm x 30 cm (19¾ in x 12 in)
★ Cotton lining 25 cm (10 in)
★ Latex glue
★ Metal zip 20 cm (8 in)
★ Leather machine needle
★ Zip foot
★ Masking tape
★ Bulldog clips
★ Latex gloves
★ Matching leather or suede tassel (optional)

LEVEL: INTERMEDIATE

DRAFTING THE PATTERN

It's best if you use card for the outer bag strip pattern, as you cannot pin a pattern onto leather as it will leave holes. Instead draw around the pattern with a biro and then cut out the shape.

1. Outer bag – draw a rectangle measuring 9 cm x 25 cm (3½ in x 10 in). Label 'LEATHER/SUEDE STRIP'. Cut out.

2. Lining – draw a rectangle measuring 44 cm x 25 cm (17½ in x 10 in). Cut out.

CUTTING OUT

3. Cut 4 strips of suede.

4. Cut 2 strips of leather.

5. Cut 6 strips of backer.

6. Cut 1 lining piece.

7. Cut two little tabs out of either the leather or suede. They need to be about 3 cm (1⅛ in) long and the width of the zip tape.

MAKING

The seam allowance is 1 cm (½ in).

THE PATCHWORK

8. Iron on the leather backer to the suede and leather strips. The backer works like interfacing. It is shiny on one side – this is the glue. It fuses onto the back of the leather or suede. Use a lowish heat setting on the iron and turn off the steam.

9. Take one strip of suede and one strip of leather and place the long edges right sides together. Use the bulldog clips to hold them together. Select stitch length 3 on your machine and then stitch together.

10. Take a second strip of suede and place it with the other long side of the leather strip. Clip together as before and stitch in place. One side of the bag is complete. Ⓐ

11. Repeat steps 9 and 10 for the other side of the bag.

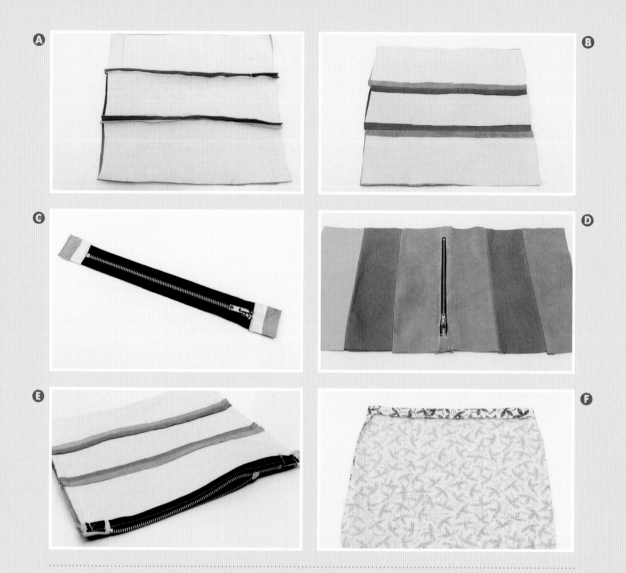

12. Using latex glue, glue the seam allowances down so they are open and flat. We can't iron them into place so the glue presses them open. **B**

THE ZIP

13. Keeping the zip closed and right side facing up, place the tabs at the ends of the zip. Use masking tape to hold in place. This allows you to sew over the leather or suede. Stitch across the tab, 2 mm (⅛ in) from the edge. Remove the masking tape, being careful not to rip the stitches. **C**

14. Take the top edge of one of the bag pieces (this could be either long side) and place it wrong side down onto the top of the zip tape. Make sure the zip is sitting centrally with even lengths of the tabs at each end. The top of the bag must be sitting right up to the metal teeth but not overlapping. Use masking tape to hold it in place. Trim the tabs so they are in line with the sides of the bag.

15. Attach the zip foot to your machine. Stitch the bag to the zip, about 3 mm (³⁄₁₆ in) from the top edge of the leather.

16. Repeat steps 14 and 15 with the other side of the zip and bag. **D**

JOINING THE BAG TOGETHER

17. Open the zip and fold the bag right sides together, aligning the three unstitched edges and corners. Clip in place.

18. Stitch together, starting from the top right-hand edge, pivoting at the corners. Cut off the top and bottom corners and trim the seam allowance to 5 mm (¼ in). **E**

LINING

19. Fold the lining in half, short ends together. Pin the sides and stitch in place. Cut off the bottom corners.

20. Fold over 1.5 cm (⅝ in) along the top edge and press flat. Turn the right way round. **F**

21. Drop the leather or suede bag into the lining. Pin the folded edge of the lining to the back of the zip tape. Slipstitch in place. **G**

22. Turn the bag the right way around and push out the corners as best you can. Attach the tassel to the zip.

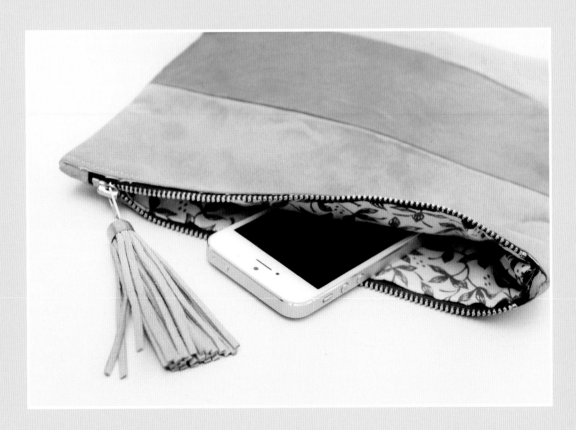

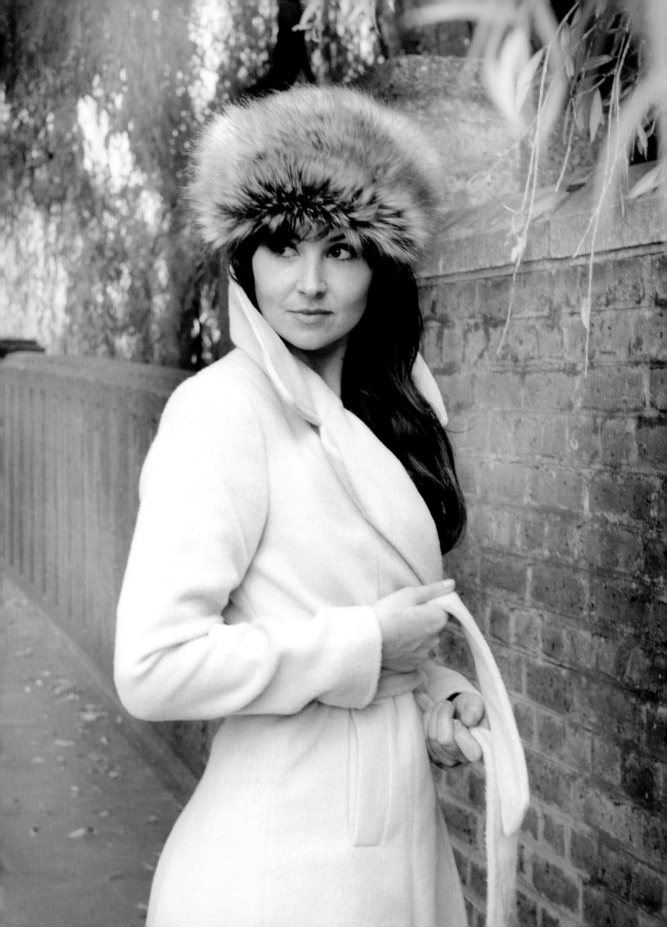

1960s
FUR HAT

There is something wonderfully stylish about a fur hat. Put it on and you instantly have Dr Zhivago chic. The design for this hat comes from the 1960s and I like to think it is something Jackie O would have worn.

We will be using faux fur for this project.

YOU WILL NEED

★ 30 cm (12 in) faux fur

★ 30 cm (12 in) satin for lining

★ Fusible interfacing

★ Petersham ribbon – the circumference of your head plus a little extra

MEASUREMENTS REQUIRED

❶ Measure around the circumference of your head. Add 3 cm (11/8 in) for ease.

❷ Take this measurement and divide it by π (Pi 3.14). This will give you the diameter of the hat. However, we need the radius, so divide again by 2.

LEVEL: INTERMEDIATE

TOP TIPS FOR WORKING WITH FAUX FUR

• Pin the pattern pieces to the back of the faux fur – not the furry side!

• Trim the fur down on the seam allowance. This will make sewing much easier.

• Use a long stitch length on the machine. I used stitch length 3.

• Have a vacuum cleaner to hand and clean up as you go. You don't want your machine to get clogged up.

• Be prepared to get covered in it!

DRAFTING THE PATTERN

1. To get a circle for the top of your hat, take measurement ❷ and put a drawing pin in a tape measure at this point. Then pin the tape measure to the centre of a piece of paper. With a pencil, mark the end of the tape measure, moving it round, and every few centimetres make a mark to give you a circle. Join up the points to create a smooth line.

2. Add a 1 cm (½ in) seam allowance to the edge. Label 'TOP HAT, CUT ONE IN FUR, INTERFACING AND LINING'.

3. On another piece of paper, draw a rectangle that measures ❶ plus a 2 cm (¾ in) seam allowance by 11 cm (4⅜ in). Label 'HAT BAND, CUT ONE IN FUR, INTERFACING AND LINING'.

MAKING

The seam allowance is 1 cm (½ in).

4. I recommend that you make up a toile of the hat in calico first. It shouldn't be so tight that it's uncomfortable. There needs to be room to fit a couple of fingers inbetween your head and the inside of the hat.

5. Trim the fur down around all of the seam allowances. ⓐ

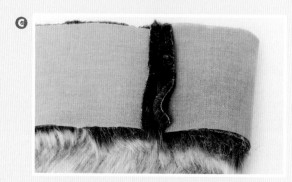

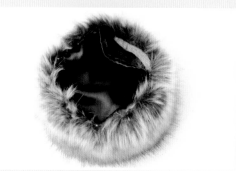

6. Interface both the fur top and band. Be careful with the heat settings. Faux fur can melt under heat, so test it out on a little piece first. **B**

7. Taking the band, place the two shorter ends right sides together. Pin and stitch in place. **C**

8. Fold in half. Pin the centre point.

9. Taking the top, mark two half points on the edge of the hat with a pin.

10. With the pile facing upwards, pin the band to the top, placing right sides together, and aligning the half points on the top to the seam and the other pin on the band. Pin thoroughly and stitch in place. **D**

11. Repeat steps 7–10 with the lining.

12. Iron up the bottom edge of the lining band by the seam allowance plus an extra 2 mm (⅛ in). Drop the lining into the hat, wrong sides together.

13. Folding as you go, pin the bottom edge of the hat to the bottom edge of the lining. The lining should sit 2 mm (⅛ in) from the folded edge of the hat. Pin and slip stitch in place. **E**

14. Take the strip of Petersham and cut it to measurement **❶**. Pin to the inside bottom edge of the hat, aligning the Petersham edge with the lining edge. Fold back the end and allow it to overlap the beginning of the Petersham. Backstitch in place 3 mm (³⁄₁₆ in) from the bottom edge. Overstitch at the overlap to anchor the end down.

Vintage
LACE NECKLACE

For this project I have used a selection of vintage doilies that I picked up at a car boot sale. You could use any lace motif – it doesn't have to be doilies.

YOU WILL NEED

★ Lace doilies or motifs
★ PVA and water with a bowl to mix
★ Cling film
★ Plate or tile
★ Paint brush
★ Nymo thread
★ Needle
★ Necklace chain (you need to be able to stitch through the chain loops), cut into two even lengths
★ Findings to fasten the necklace
★ Jump rings
★ Jewellery pliers
★ Cling film

LEVEL: EASY

1. If using doilies, cut out the centres (you can choose to have as many or as few as you want). **A**

2. Make a mix of PVA and water, with the same quantities of each.

3. Put some cling film on a plate or tile. Then lay the circles or motifs on the plate/tile and brush them with PVA mix until they are covered on both sides. Leave to dry on the plate/tile for about a day until they go stiff. **B**

4. Remove from the plate/tile – make sure no cling film is attached.

5. Lay the circles or motifs on the table to work out the best arrangement. Each one must overlap the next. Take a photo to use as reference.

6. Take the first lace shape in the sequence and, using a single thread with a knot at the end, start with a

A

B

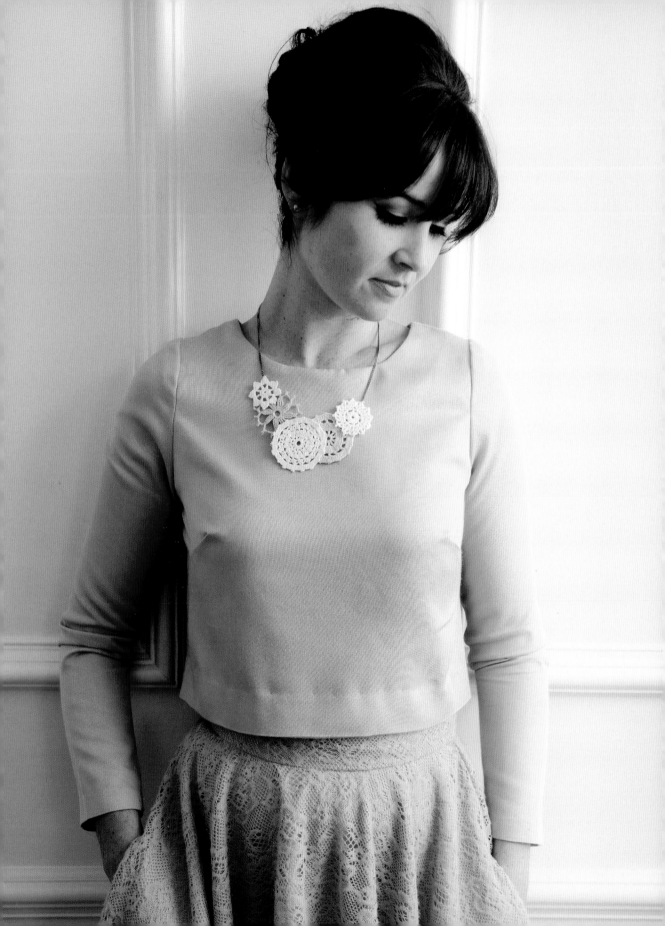

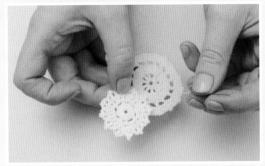

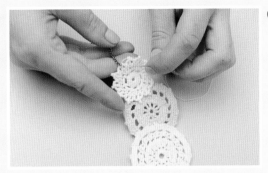

small stitch to anchor the thread, making sure it doesn't show from the right side. The PVA hardens the lace, which makes it trickier to sew through. You can also sew through the holes or gaps in the lace.

7. Take the second circle or motif in the sequence and join to the first with a few little overstitches, coming up and back down into the back of the circle or motif. Once you have done enough stitches to ensure the join is strong enough, finish with a little secure stitch and fasten at the back. **C**

8. Repeat this process until all the shapes are joined together.

9. Take one of the chain lengths and stitch through the end chain loop and into the lace a few times, so that it's strong. Make sure you tie off at the beginning and end on the underside of the necklace. Repeat on the other side with the second length of chain. **D**

10. Using pliers and jump rings, attach the fastenings to the end of the chain.

Vintage
CURTAIN HANDBAG

I found this curtain fabric in a second-hand shop in Dorset. There was enough material to make a skirt and now I've used the remaining pieces to make this bag. To give it a bit more strength, I've used leather backer. This is what gives the bag its structure.

YOU WILL NEED

★ Vintage curtain approx. 1 m x 0.5 m (40 in x 20 in)

★ Lining fabric approx. 0.5 m (20 in)

★ Leather backer or medium-weight interfacing (same amount as vintage curtain)

★ Leather straps with stitching holes

★ Topstitching thread

★ Magnetic 'Maglock' bag closures with grips (comes as a pair)

★ Craft knife

LEVEL: INTERMEDIATE

DRAFTING THE PATTERN

1. You can make the bag whatever size you want. Follow these steps for the same size as my bag. They already include a 1 cm (½ in) seam allowance to all edges.

2. On a piece of paper draw a rectangle measuring 42 cm x 36 cm (16 in x 14¼ in). Cut it out. Label the piece 'MAIN BAG, CUT TWO' and label one of the long edges 'TOP' and the other 'BOTTOM'. The grainline should be parallel to the sides.

3. From the bottom corners, square across 5 cm (2 in). Then square up another 5 cm (2 in) and then square across again a further 5 cm (2 in). Cut along these lines, taking a step out of the bottom corners.

4. On a separate piece of paper, draw a rectangle measuring 42 cm x 9 cm (16 in x 3½ in). Cut it out. Label this 'FACING, CUT TWO'. The grainline should be parallel with the shorter ends.

5. For the lining, trace off the main bag pattern piece, including the grainline. Measure down 8 cm (3¼ in) from the top edge and draw a parallel line. Cut along this line and around the rest of the pattern. Label this pattern 'LINING, CUT TWO'.

CUTTING OUT

Cut the following pieces:

6. 2 x main bag in vintage fabric and backer or interfacing.

7. 2 x facing in vintage fabric and backer or interfacing.

8. 2 x lining in a cotton lining fabric.

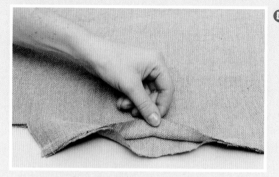

MAKING UP

Seam allowance is 1 cm (½ in).

9. Iron the backer or interfacing onto the back of the vintage fabric pieces.

10. Place the two main bag pieces right sides together and pin along the sides and along the bottom edge. Stitch together and press the seams open.

11. At the bottom corners of the bag, align the side seam with the bottom seam, right sides together. Pin and stitch together. Press the seams open. Ⓐ

12. Take one of the facing pieces and find the centre of one of the long edges. Then measure down 3.5 cm (1⅜ in) at this point and place a pin in to mark the point. Ⓑ

13. Place the prongs of the Maglocks on either side of the pin and mark their position with an air-erasable pen or pencil.

14. Using a craft knife, make two small slits where the marks are.

15. Push the Maglock prongs through the slits and slot the back discs over the prongs. Using closed scissors, fold the prongs in so that one sits on top of the other and the Maglocks are secure. Ⓒ

16. Repeat steps 12 to 15 with the other facing piece, making sure the maglocks are perfectly aligned with one another.

17. Place the two facing pieces right sides together and pin along the shorter sides. Stitch together and press the seams open.

18. Place the lining pieces right sides together and pin along the side seams. Stitch together and press the seams open.

19. Pin the bottom of the lining right sides together, leaving a 15 cm (6 in) gap in the middle. Stitch together, leaving

the 15 cm (6 in) gap open. Press the seam open and press over the seam allowance in the gap to align with the stitched seam. **D**

20. Place the top of the lining right sides together with the bottom of the facing (the opposite side to where the Maglock is). Align the seams and edges and pin in place. Stitch together. Press the seam down towards the lining. **E**

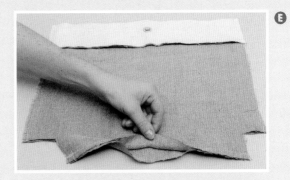

21. Turn the main bag the right way round and decide where you want the straps to sit. Mark the position on both sides with pins. Using a needle and topstitching thread, backstitch through the perforated holes in the straps. Make sure you start and finish with a secure stitch and a knot. **F**

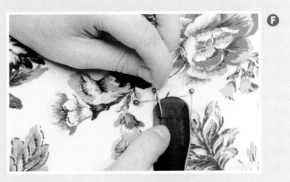

22. Turn the main bag the right way round and let the straps fold down to the outside of the bag. Keeping the lining inside out, slot the lining into the bag, right sides together and line up the top edges. Match the side seams and pin all the way round the top edge. Stitch together.

23. Pull the outer bag through the gap in the lining. Keeping the straps out of the way, press the top of the bag so that the seam is sitting right on the edge. Topstitch 2 mm (⅛ in) from the top edge. **G**

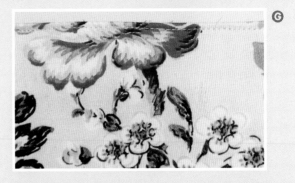

24. Pin the folded edges of the gap together and edgestitch closed. Push the lining down inside the bag. **H**

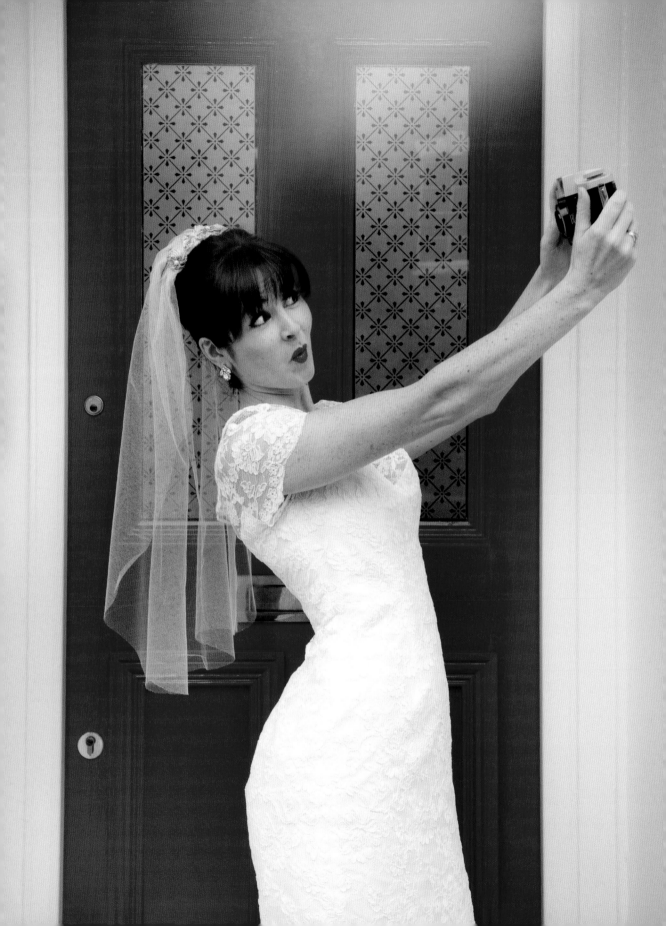

Veil

WITH VINTAGE BUTTONS OR BROOCHES

Before I set up Sew Over It I worked in bridal wear. I wanted to share a technique I learnt with you all – how to make a veil. They are really quite simple. I think they are best if made out of silk tulle, but it is expensive. If you can't afford it, a 'crunchy' tulle is best rather than something soft and limp. I attached vintage brooches to mine.

YOU WILL NEED

★ Tulle – for a short veil I used a piece 75 cm long by 1 m wide (29½ in x 39½ in). For a fuller veil, use a wider piece and a longer piece if you want it longer. You also need a little for wrapping the comb.

★ Clear comb

★ Vintage buttons or brooches

LEVEL: EASY

SOME STYLE GUIDELINES FOR VEILS

• Short veils can be whatever length you want, but look best if they sit below the shoulder and above your bottom.

• If you do not want to draw attention to your hips, make sure your veil finishes above or below this point so that the eye is drawn away from there.

• If you are making a full-length veil, make sure it either matches the hem of your dress or extends over it.

• To add height, wear the veil on top of your head and use a wide piece of tulle so you have lots of gathers. But remember, if you are petite you don't want the veil to 'wear you' – you can get lost in too many gathers.

MEASURING THE LENGTH OF THE VEIL

Hold the end of a tape measure at the point on your head where you will wear the veil. Let it hang down your back and ask someone to make a note of the point where you want the hem of the veil to sit.

CUTTING TULLE

There isn't the same selvedge on tulle as on other fabric but there should be a straight edge running down either side. Use this to square off the bottom and top edges. Use an air-erasable pen or pins to mark the cutting lines. If using pins, sit them just inside of where you need to cut. You need a pattern master or set square and a metre rule to get straight edges. The best thing about tulle is it doesn't fray!

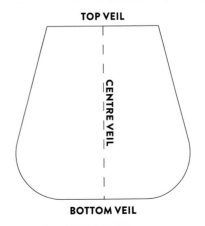

TOP VEIL

CENTRE VEIL

BOTTOM VEIL

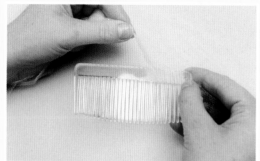

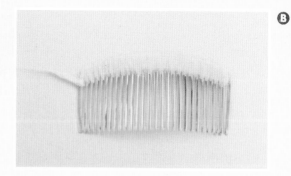

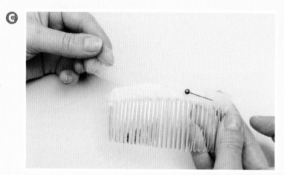

MAKING

COVERING THE COMB

1. Take a strip of tulle that is about 2.5 cm (1 in) wide and at least three times the length of the comb. Starting at one end, wrap the tulle around the top of the comb, threading the tulle through the gap in between the prongs.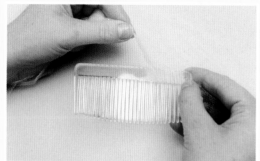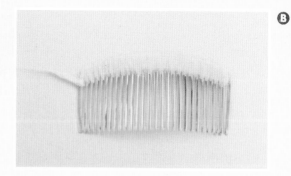

2. Then take another strip of tulle that measures four times the width of the top of the comb and is the length of the comb, plus 2 cm (¾ in).

3. Fold the tulle in half lengthways and iron in a central crease. Then fold one raw edge into the crease and then the other, pressing to form two other fold lines. This will create binding to cover the wrapped tulle on the comb.

4. Tuck under 1 cm (½ in) on either end of the binding so there are no raw edges. Place the binding over the end of the comb so that it is sandwiching the comb. Pin the folded edges to the bottom of the wrapped tulle on either side of the comb.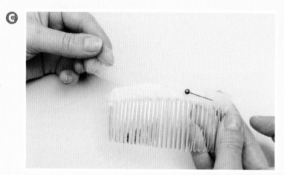

5. Slip stitch in place. At the ends, catch the folded edges with overstitches.

THE VEIL

6. Press the tulle to remove creases. If it's silk, it's best to steam it, holding the iron just above and allowing the steam to smooth it out. If it's a man-made fibre be careful not to melt it.

7. Fold the tulle in half lengthways aligning the raw edges. Using pins mark out the curved sides at the bottom of the veil. Starting from the fold, keep the first half of the hem perpendicular to the foldline. Then start to curve towards the sides. The curve must be even and smooth. The pins must go through both layers (see diagram on page 117).

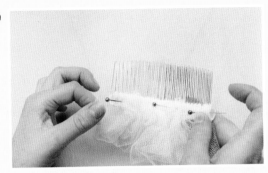

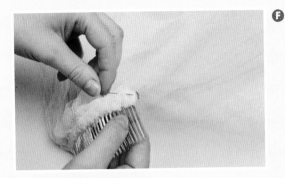

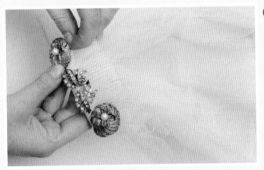

8. When you reach the sides, start to grade in the sides a little, working towards the top of the veil. This must be a gentle angle, getting narrower at the top.

9. Cut just below the pin line. If this is too scary then you can always mark the cutting line with a pen.

10. At the top straight edge, run a line of gathering stitch (tacking stitches) 1 cm (½ in) from the cut edge. Leave the tails of thread at either end. Pull the ends so that the veil gathers up. **D**

ATTACHING THE VEIL TO THE COMB

11. Lay the comb face down on the table. Lay the veil next to it with the gathered end facing the comb.

12. Pin the gathered end onto the top of the veil. The raw edge must sit at the bottom edge of the binding on the comb. Adjust the gathers so that they are even. **E**

13. Overstitch the veil edge to the tulle on the comb. Remove the gathering stitch. **F**

14. Using backstitch, sew along the veil at the point where it touches the top edge of the comb. This is to keep the veil attached to the top of the comb when it is flipped round.

15. Flip the veil over the comb so that the veil hem is now facing the same direction as the prongs. **G**

16. The veil is ready to wear! If you want to attach vintage brooches or buttons, sew these directly onto the veil and through the tulle onto the comb. **H**

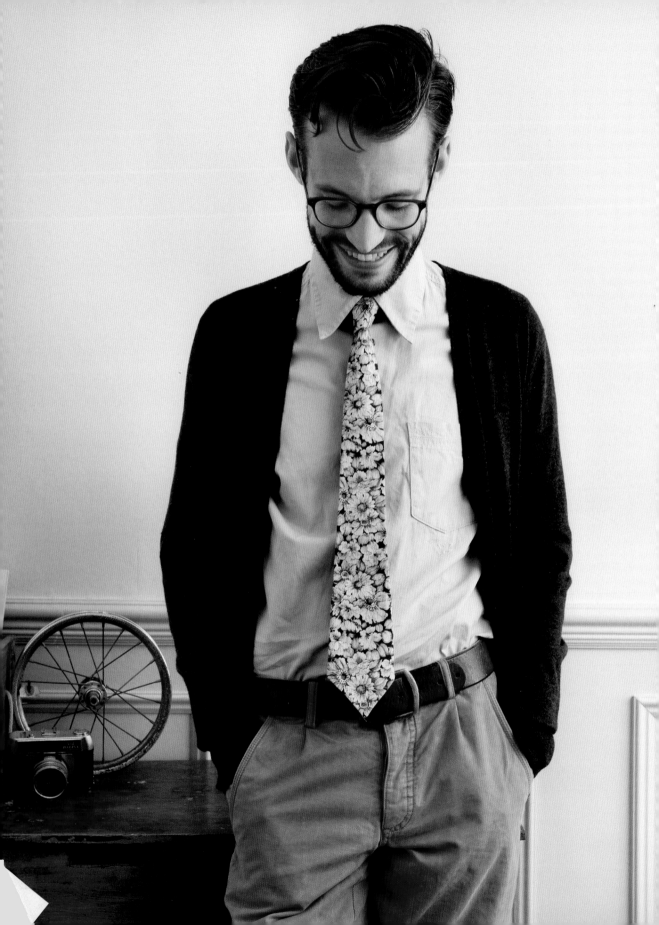

Vintage
COTTON MEN'S TIE

The perfect present, a handmade vintage tie! For this I used some vintage cotton. You must use a lightweight fabric. I lined the tie with satin.

YOU WILL NEED

★ 80 cm (31½ in) length of fabric (you won't use most of this but you need this length as the tie is cut on the bias)

★ 20 cm (8 in) lining – I used satin

★ 20 cm (8 in) domette interlining

LEVEL: EASY

DRAFTING THE PATTERN

Seam allowances are included.

FRONT TIE PIECE

1. Draw a vertical line on a piece of paper that is 71 cm (28 in) long. There needs to be 10 cm (4 in) of extra paper beyond this line. Label it AB.

2. From the bottom of the line, A, measure up 9 cm (3½ in). Then square out 9 cm (3½ in) either side of the line. Label these points C and D.

3. Join C and D to A, creating a point.

4. At B, square out 4.5 cm (1¾ in) either side of the line. Label these points E and F.

5. Join E to C and F to D using a metre rule.

6. Extend line DF a further 9 cm (3½ in) and label G. Connect G to E.

7. The grainline should be parallel to either line AC or AD.

BACK TIE PIECE

8. Draw a vertical line on a piece of paper that is 71 cm (28 in) long. There

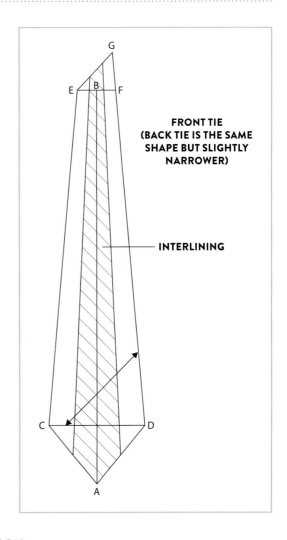

FRONT TIE
(BACK TIE IS THE SAME SHAPE BUT SLIGHTLY NARROWER)

INTERLINING

needs to be 10 cm (4 in) of extra paper beyond this line. Label it AB.

9. From the bottom of the line A, measure up 5.5 cm (2¼ in). Then square out 5.5 cm (2¼ in) either side of the line. Label these points C and D.

10. Join C and D to A, creating a point.

11. At B, square out 4.5 cm (1¾ in) either side of the line. Label these points E and F.

12. Join E to C and F to D using a metre rule.

13. Extend line DF a further 9 cm (3½ in) and label G. Connect G to E.

14. The grainline should be parallel to either line AC or AD.

DOMETTE/INTERLINING

15. At the bottom of the tie connect C and D in a line from AB. Then measure out from line AB 4.5 cm (1⅝ in) on either side along line CD.

16. At the top of the tie, connect E and F in a line. Then measure out from line AB 2 cm (¾ in) on either side.

17. Connect the points at the top of the tie to the ones at the bottom. Extend the lines until they meet the bottom and top edges of the tie.

18. Trace off this shape with the grainline in the same position.

19. Repeat the above process for the back tie, but measuring out 2 cm (¾ in) from the central line AB at both the top and bottom.

20. The grainline can run down the central line for this.

LINING

21. Draw a parallel line to CD, 1 cm (½ in) above it.

22. Trace off the pointed ends from this line down from the front tie. Repeat this step for the back tie to create back lining.

CUTTING OUT

23. Front tie – cut one.

24. Back tie – cut one.

25. Front domette or interlining – cut one.

26. Back domette or interlining – cut one.

27. Front lining – cut one.

28. Back lining – cut one.

MAKING

The seam allowance is 1 cm (½ in).

29. Place the front and back tie pieces right sides together at the diagonal ends. The straight edges should align but the corners should extend out at either side (the same amount on each side). Pin in place. **Ⓐ**

30. Stitch with a 1 cm (½ in) seam allowance starting at the 'v' on one side and finishing at the same point on the other side. Press the seam open and cut off the points. **Ⓑ**

31. Place the front lining, right sides together, with the pointed end of the front tie. Pin along the diagonal edges and stitch in place, pivoting at the point. Cut off the point. **Ⓒ**

32. Turn the right way round and press so that the tie slightly rolls over the edge, hiding the lining.

33. Repeat steps 31–32 with the back lining and tie.

34. Fold over 1 cm (½ in) of one of the long sides of the tie and press flat. **Ⓓ**

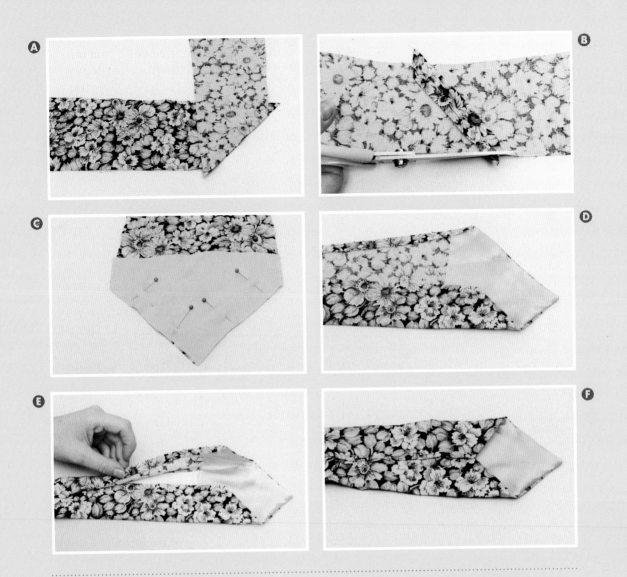

35. Lie the tie flat, wrong side facing up, and place the domette down the middle. The pointed ends should tuck under the lining. The other ends should overlap each other.

36. Then press the tie into its shape, using the domette edge as a guide, folding the side with the raw edge first and then the side with the folded edge, so it overlaps. Pin in place. You will need to take care at the pointed ends to make sure they are evenly pressed on both sides. **E**

37. Slip stitch the folded edge down, catching the domette as you go. Just be careful you don't stitch through to the tie front! **F**

Vintage home

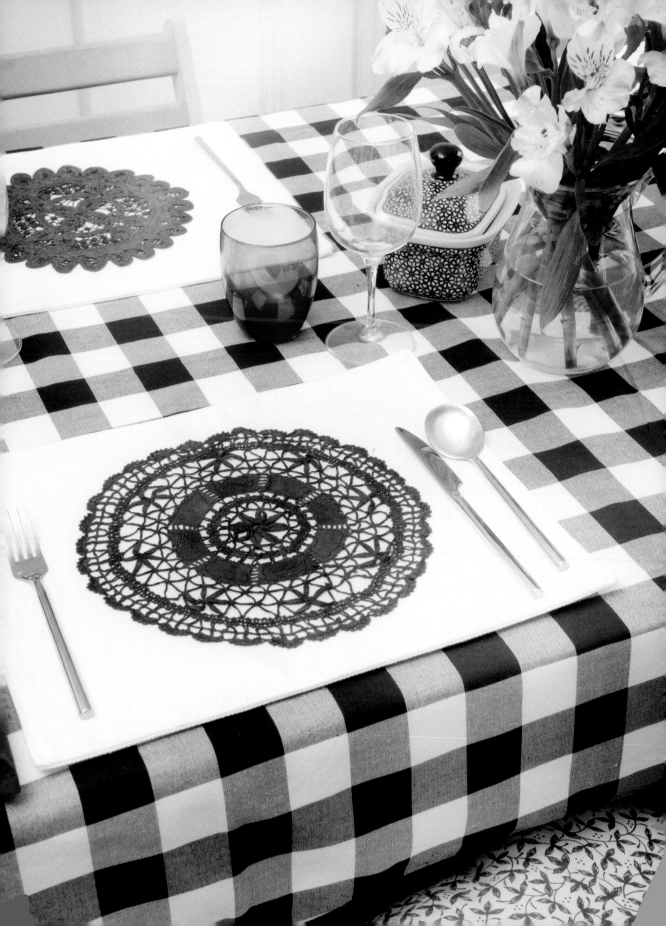

Doily
PLACEMATS

I have a thing for lace doilies and I can't stop myself collecting them. Here is a way that they can be reinvented.

1. Make a pattern for the placemat. Mine were 32 cm x 38 cm (12¾ in x 15 in) but they can be any size you want.

DYEING THE DOILIES

2. Gently wash the doilies.

3. Pop your rubber gloves on and mix up the dye and salt according to the manufacturer's instructions.

4. Drop the doilies into the dye and make sure they are fully covered. If you want them to become the exact colour advertised on the packet, then dye for as long as recommended. If you want a pastel colour, leave in for a quarter of the time. **A**

5. Rinse and wash following the manufacturer's instructions. Be gentle with them – don't put them in the washing machine.

6. Dry flat so they don't lose their shape.

7. Once dry, iron them back into their original shape.

MAKING THE PLACEMATS

The seam allowance is 1 cm (½ in).

8. Using the pattern in step 1, cut out two pieces per placemat.

9. Pin the ironed doily on the centre of the placemat, using a tape measure to ensure it is centred accurately. **B**

10. Tack the doily in place. Your stitches can be nice and big – don't worry about being neat! **C**

11. Lower the feed dog on the machine and attach the embroidery foot. Select a narrow zigzag stitch (1.5) with an average stitch length (2). Start working your way around the doily, couching over the edge of the design. You want the stitches to be discreet, so stay on the doily as much as you can. You may need to start and stop, as it can be hard to get round the doily in one go. To start and finish, allow the needle to stitch on the spot for a few stitches to anchor the thread. Make sure you sew around the edge and anchor the doily in a few places in the middle.

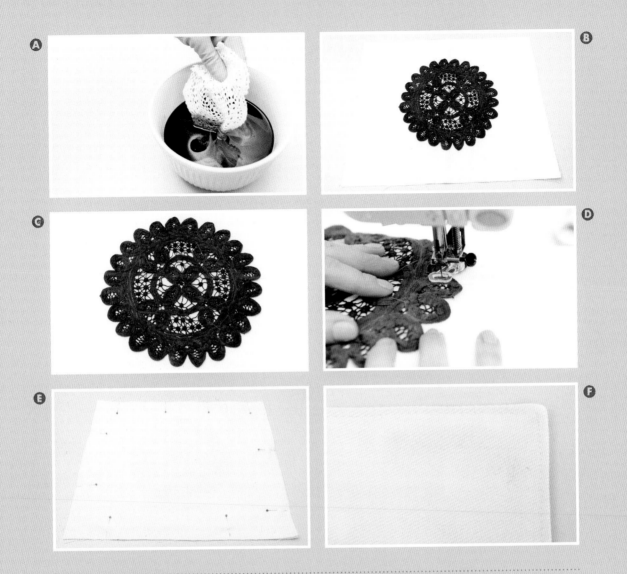

It depends on the design but you can follow the outline of flowers or patterns. Trim away loose threads. **D**

12. Place the other placemat piece right sides together with the doily piece. Pin in place. **E**

13. Starting in the middle of one of the long edges, sew all the way round, leaving a 15 cm (6 in) gap in the middle of one of the long edges. Trim the corners and turn the right way round.

14. Using a knitting needle or something similar, such as a chopstick, push the corners out from inside the placemat. Then press the placemat flat, making sure the seam is right on the edge. At the opening, tuck in the raw edges and press so that it lines up with the stitched edges.

15. To finish, edgestitch around the placemat about 2 mm (⅛ in) from the edge, pivoting at the corners. **F**

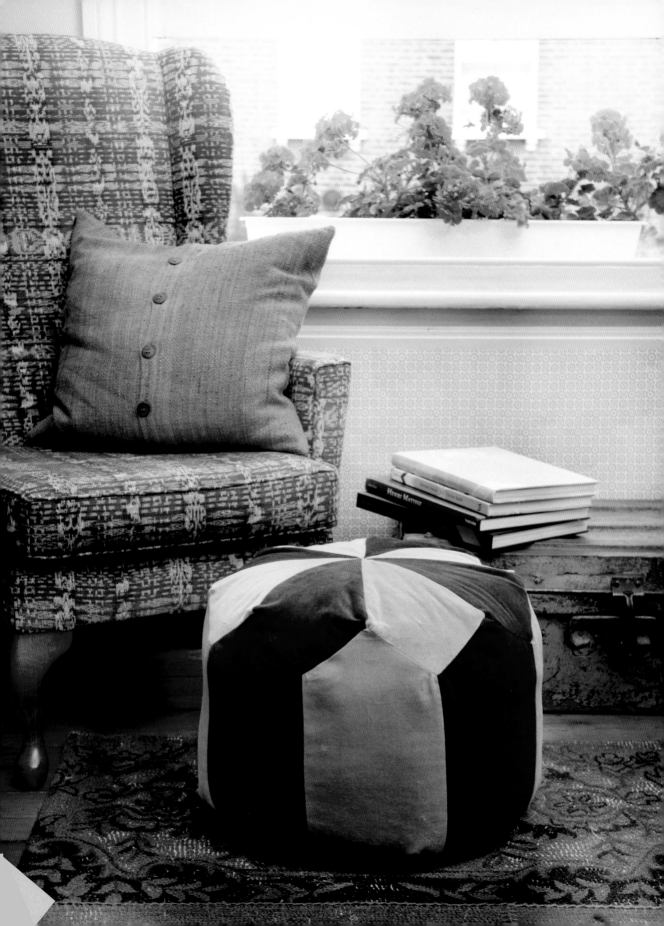

Patchwork
POUFFE

I designed this for a class but I thought it would be nice to share it with you too. It was something I thought was missing in our living room and is great as a little seat or a foot rest. I have raided my collection of vintage fabrics to make this up. Curtain fabric is perfect as it is just the right weight.

The patchwork pieces are provided on pages 154–155. You will need to photocopy and enlarge them by 200 per cent. For the base of the pouffe and the inner bag pattern pieces that you will need to make, follow the instructions below.

YOU WILL NEED

★ 40 cm (15¾ in) of fabric, 1 and 2 (used for the patchwork)

★ 30 cm (12 in) of fabric, 150 cm (60 in) wide (for the base). If you can't find fabric wide enough, cut two strips that amount to the length needed for the base, plus a seam allowance, and join.

★ 2 m (80 in) of calico (for the lining)

★ Polystyrene balls to fill, approx. 0.142 cubic metre (5 cubic feet)

★ Ribbon or drawstring – 160 cm (64 in)

★ ½ m (20 in) of velcro

LEVEL: ADVANCED

DRAFTING THE PATTERN

THE BASE OF THE POUFFE

1. Draw a rectangle measuring 27 cm x 147 cm (10¾ in x 58½ in).

LINING

TOP CIRCLE

2. Pin the 23 cm (9 in) point on a tape measure to the middle of a piece of paper. With a pencil, mark the end of the tape measure, then move it round and every few centimetres make a pencil mark. This will give you a circle. Join up the points to create a smooth line.

SIDE

3. Draw a rectangle measuring 35 cm x 147 cm (13¾ in x 58½ in).

BASE

4. Draw a line across the diameter of the top circle. Trace off half of the circle. Add a 4.5 cm (1¾ in) seam allowance to the straight edge.

CUTTING OUT

5. Vintage fabric – 8 top pieces, 8 side pieces and 1 base.

6. Lining – 1 top circle, 1 side piece and 2 base pieces.

MAKING

The seam allowance is 1 cm (½ in).

CREATING THE TOP PATCHWORK

7. Decide in which order you would like to sew the different designs. Lay them out on the table in the full circle.

8. Take two pieces and place right sides together, aligning one of the longer edges. Pin in place. Starting 1 cm (½ in) in from the top corner, stitch down, finishing 1 cm (½ in) from the bottom corner. Press the seam open.

9. Take the third piece in the sequence and pin it to the second. Follow the same steps above. Repeat this process until you have a complete circle. It is important that the seam allowances are really accurate so that all the pieces meet in a perfect point.

CREATING THE PATCHWORK FOR THE SIDES

10. Lay the side pieces out in the order you want to sew them. Take the first two pieces and place them right sides together, aligning one of the longer edges. Pin in place. Stitch from the top (pointed end), starting 1 cm (½ in) in from the corner. This time stitch all the way to the bottom edge. Press the seam open.

11. Take the third piece in the sequence and pin it to the second. Follow the steps as above until you have a strip.

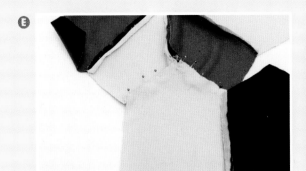

JOINING THE SIDE AND TOP PANELS

12. The top of the side panels interlock with the outside edge of the top circle. Start by lining up the first two pieces, placing them right sides together. The point of the side panel must align with the seam joining the top panels. The point of the top panel must align with the seam joining the side panels. It helps to clip into the point, but no more than 8 mm (⁷⁄₁₆ in). Pin one edge in place. **E**

13. I found it easier to work with the side panels facing me. Start sewing right on the middle of the seam (joining the sides panels). At the point you must stop 1 cm (½ in) before so that you can pivot to sew the next edge with the same 1 cm (½ in) seam allowance. After pivoting, pin the next edge together and then stitch in place. Continue working in this way, pinning the edges as you go. Finish by joining the two remaining unstitched side panels together.

ATTACHING THE BASE

14. Place the shorter ends right sides together. Pin in place leaving 4 cm (1½ in) unpinned at one end. Mark this point with a pin. This end will be the top. Stitch together up to the 4 cm (1½ in) marker pin. Press the seam open, continuing to press over the seam at the 4 cm (1½ in) opening.

15. Fold the top edge over by 1 cm (½ in) and a second time over by 1.5 cm (⅝ in). Press flat and pin in place. Edgestitch all the way round, starting and finishing at the opening. This creates a casing for a drawstring opening at the base of the pouffe. **F**

16. Fold the base in half with the seam at one edge. Place a pin on the fold line at the raw edge (bottom). This marks the halfway point.

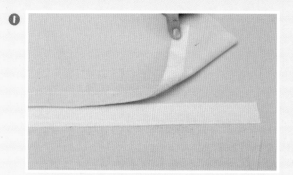

17. Fold the pouffe in half and mark the halfway points here as well.

18. Turn the pouffe the right way round and keep the base inside out. Slot the base over the pouffe, aligning the halfway points and raw edges, right sides together. Pin all the way round, easing where necessary. Stitch together and zigzag the edges to prevent fraying. **G**

19. Using a safety pin, thread a ribbon through the casing where the 1 cm (½ in) gap is. Leave the ribbon loose.

LINING BAG

THE BASE

20. Cut the Velcro to the length of the straight edge of the lining base.

21. On one of the base pieces, fold over 2 cm (¾ in) of the straight edge to the wrong side and press flat. On the other piece, fold over 2 cm (¾ in) to the right side and press flat. **H**

22. Pin the Velcro to both pieces, lining up the edge of the Velcro with the fold. It should sit on the wrong side on one and on the right side on the other. Edgestitch around the entire Velcro strip, pivoting to sew across the ends. **I**

23. Join the two pieces, using the Velcro, to make a circle.

THE SIDES

24. Place the shorter ends right sides together. Pin in place and stitch together. Press the seam open.

25. Find the halfway point by folding the side panel together, keeping the seam on one edge. Mark with a pin on both top and bottom edges.

JOINING THE LINING PIECES TOGETHER

26. Fold the top circle in half and mark the halfway points with pins. **J**

27. Place the top circle, right sides together, with the side panel, aligning both the edges and the halfway pins. Pin all the way round, easing where necessary. **K**

28. Repeat this process with the base.

29. Clip around the top circle and base seam allowances. **L**

30. Turn the right way round.

FILLING THE POUFFE

31. Make a funnel out of a large sheet of card. Pour the polystyrene balls into the lining through the Velcro opening. You will need to use a jug to add the remaining balls to top it up. Close the opening.

32. Drop the inner pouffe into the cover and pull the drawstring ribbons. Tie in a double knot to secure. **M**

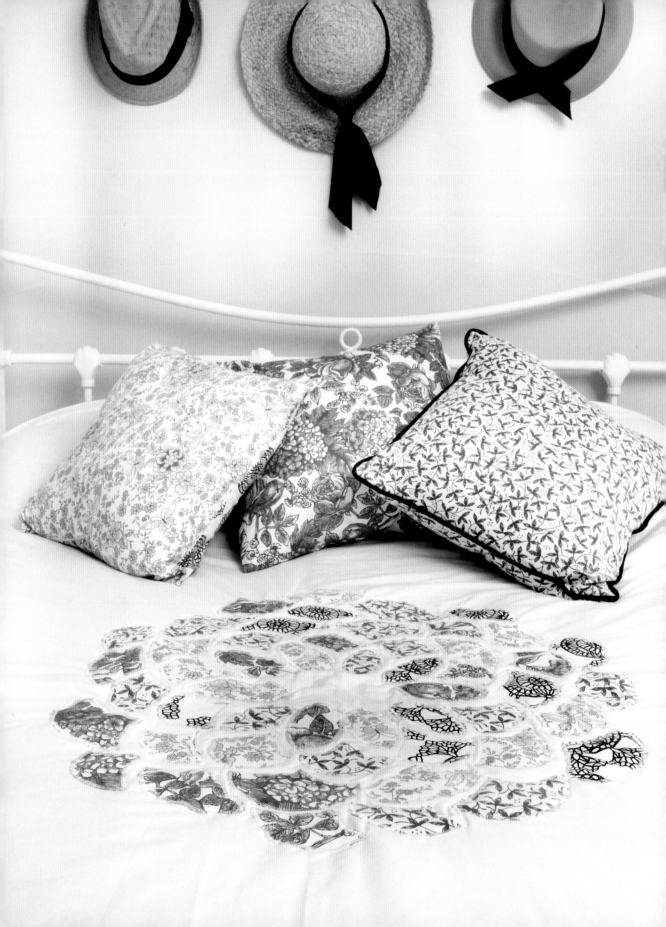

Appliqué
QUILT

Quilts are the perfect project to use up small pieces of fabric. So, all the offcuts of lovely vintage fabrics from the other things you have made can be used to create a pretty quilt. I used machine appliqué and quilting, as opposed to doing it by hand. It saves a lot of time and makes your quilt a little more durable. I made this for the double bed in our spare room, but you can, of course, make the quilt any size you want.

YOU WILL NEED

★ Vintage fabrics for appliqué

★ 2 white flat sheets (double-sheet size)

★ Cotton batting (double-sheet size)

★ Bondaweb

★ Basting spray or curved safety pins

Pre-wash the flat sheets and the cotton batting before you start.

LEVEL: INTERMEDIATE

DESIGN

1. I created a design based on a flower stencil. I enlarged it on a photocopier and stuck the pieces of paper together. I traced off the individual shapes and numbered them so that I could keep track of their position in the design. I then cut them out.

2. You could choose any design you want, just be aware that little pieces will be more fiddly than larger pieces.

APPLIQUÉ

3. Iron the Bondaweb to the wrong side of your vintage fabrics.

4. Place the paper templates face down onto the Bondaweb and trace around the shapes. Trace each piece number as well, if relevant.

5. Cut out the Bondawebbed shapes.

6. Iron out any creases in one of the sheets. Find the centre point of the sheet by folding it into quarters. Mark with a pin.

7. Place an extra sheet or towel on the workspace (you may need to use the floor). Lay the sheet flat with the right side facing up. Position the pieces in their sequence, using your original image as reference and peel the paper off the back as you go. **A**

8. Then, following the manufacturer's instructions, iron the Bondawebbed pieces onto the sheet. This is to keep them secure when you machine around the edges. **B**

QUILTING

9. Iron out any creases in the remaining sheet. Lay the bottom sheet flat, wrong side up. Then lay the batting sheet on top and the top sheet right side

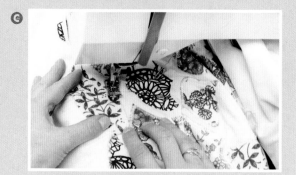

up on top of that. Each piece must sit centrally on the next. Trim the bottom layer so that it is the same size as the batting. Trim the top layer so it is 6 cm (2½ in) smaller than the batting on all edges. This is so there is room for the top layer to move when you are quilting.

10. To use the basting spray, take the top sheet and batting away and spray the top of the bottom sheet. Place the batting back down, aligning the edges. This will secure the two fabrics together. Then spray the batting and lay the top sheet on top, making sure you keep the 6 cm (2½ in) border on all edges. If you don't have basting spray you can also use curved safety pins.

11. Roll the quilt tightly at one side so that you can fit it under your machine. It will be a squeeze!

12. Put your machine onto a zigzag with a really short stitch length (0.5 mm)

so it stitches a satin stitch. You can choose the stitch width depending on how visible you want it to be. Starting in the middle of your design, stitch around the edge of the pieces, pivoting at the corners and sharp curves so that you keep to the outline of the shape. The zigzag should be half on the vintage fabric shape and half on the sheet, binding the edges. **C**

13. Work your way round each motif, from the centre out. **D**

14. When you have finished, lay the quilt flat and trim the batting and bottom sheet so that they match the top sheet.

BINDING

15. We are going to use the excess fabric cut off from the bottom sheet for the binding. Cut 4 strips for each four sides of the quilt. The strips for the top and the bottom of the quilt can be the same length as the quilt, the sides

must be 2 cm (¾ in) longer to include seam allowance plus the finished width of the top/bottom binding. You can make the binding as wide as you like (although keep in mind, this will be determined by the excess fabric). Mine is 10 cm (4 in) wide so I cut my strips, 22 cm (8¾ in) wide including seam allowance.

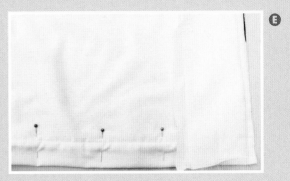

16. Iron over 1 cm (½ in) along one long edge of all strips.

17. Place the strip for the top and the bottom quilt, right sides together with the top of the quilt. Align the raw edges and pin in place. Then stitch with 1 cm (½ in) seam allowance.

18. Fold over the binding to the back of the quilt. Pin the binding in place from the back. The folded edge of the binding should sit in line with the seam. Slip stitch the back down. Gently press the binding flat. Remove the pins from the back of the quilt and repin the binding from the front to help keep the binding flat whilst you are finishing the two remaining edges.

19. Then, taking the remaining two strips, fold over the ends by 1 cm (½ in). Place the strips right sides together with the sides of the quilt. The ends of the strips should overlap with the ends of the binding at the top and bottom of the quilt.

20. The folded ends of the strips should sit flush with the edge of the quilt. Pin in place and stitch with 1 cm (½ in) seam allowance. **E**

21. Fold over the binding in the same way as you did for the top and bottom and pin and slip stitch in place. **F**

22. Then slip stitch the open ends of the binding. Gently press the binding at the sides. **G**

Lace
LANTERNS

These little lanterns look so pretty when they are lit. Perfect for weddings or your dining table. I used broderie anglaise as the fabric but you could use any lace.

YOU WILL NEED

★ Glass jars
★ Broderie anglaise (approx. 10 x 25 cm (4 x 10 in) per jar). I hand-dyed some of mine – see page 126.
★ Pinking shears
★ Thread

LEVEL: EASY

MAKING

The seam allowance is 1 cm (½ in).

1. Measure both the height of the jar and the circumference. Add 2 cm (¾ in) to the circumference. Using pinking shears, cut a strip of the broderie anglaise to these measurements. **A**

2. Place the two shorter ends of the strip right sides together. Pin and stitch together. Press the seam open. You should now have a tube. **B**

3. Turn the tube the right way out and slot it onto the jar. The bottom of the jar should be completely covered, leaving a little extra fabric at the top.

4. Take a length of thread and wrap it around the collar of the jar, creating a frilled top. Wrap it around a few times and then tie in a double knot. Cut off the excess thread. **C**

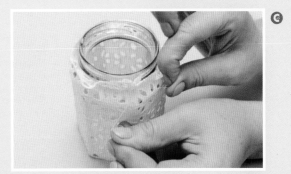

5. Drop in a tea light and place prominently on your table!

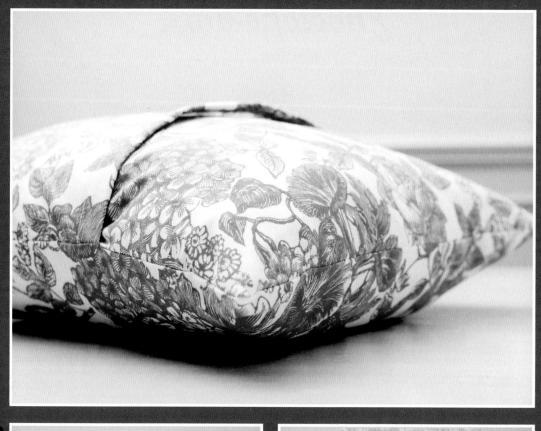

A

B

C

D

Envelope-back
CUSHION

This is the easiest way to make a cushion cover and once you have cracked the technique, you can knock out one of these in under an hour. If you have only enough vintage fabric for the front, you can always use a plain cotton for the back.

YOU WILL NEED

★ ½ m (39½ in) of fabric

LEVEL: EASY

DRAFTING THE PATTERN

1. The pattern for the front is really easy to work out. All you need are the measurements of the cushion. Mine was 45 cm x 45 cm (17¾ in x 17¾ in). Add 2 cm (¾ in) for the seam allowance, giving you 47 cm x 47 cm (18½ in x 18½ in). Draw a pattern to this size and label it 'FRONT CUSHION, CUT ONE'. The grainline should be parallel to one of the sides. (It doesn't matter which side if the cushion is square. If it's rectangular, the grainline should be going down the length of the fabric parallel with the sides of the cushion pattern rather than with the top or bottom.) If your pad is particularly full and rounded, add an extra 1 cm (½ in) to each side for ease.

2. For the back pattern, you need two-thirds of the width calculated in step 1 plus 3 cm (1½ in) for a turning by the same length from step 1. So mine worked out at 30 cm plus 3 cm (12 in + 1¼ in) turning x 47 cm (18½ in). Label 'BACK CUSHION, CUT ONE PAIR'. The grainline should be parallel to the edge for turning/overlap.

MAKING

The seam allowance is 1 cm (½ in).

3. Lay out your two back pieces face up, and decide which long edges will be in the centre of the cushion back. This is very important if the print on your fabric has a direction. Then create a hem along these edges by folding over 1 cm (½ in) and pressing with the iron. Then fold under a further 2 cm (¾ in) and press again. If you want, you can also pin this hem down.

4. Edgestitch in place. **Ⓐ**

5. Place the cushion front right side up on the table. Then take one of the back pieces and place it right sides down, aligning the raw edges. Then place the second back piece, right sides down on top of that. Pin all the way round. **Ⓑ**

6. Stitch in place, pivoting at the corners.

7. Clip the corners about 2 mm (⅛ in) from the stitch line. **Ⓒ**

8. Turn the cushion cover the right way round, and use snips or a needle to tease out the corners. **Ⓓ**

9. Press the seams flat from the right side, making sure the seams are right on the edge (not tucked in).

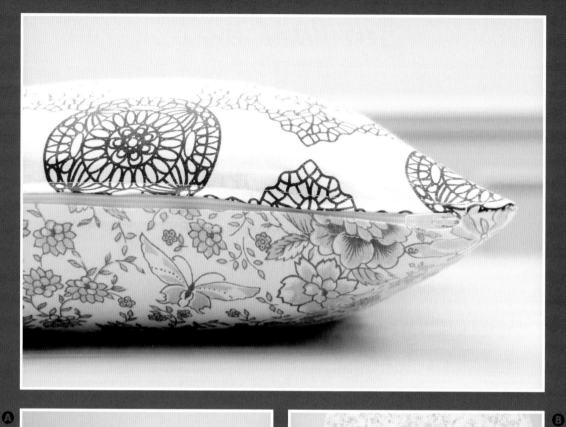

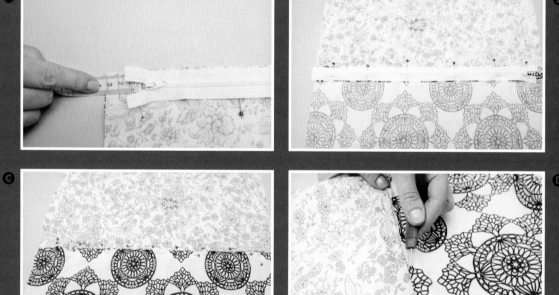

Zip-fastening
CUSHION

These cushions look very professional. Either make them with a normal zip or an invisible zip.

YOU WILL NEED

★ ½ m (19¾ in) of fabric per cushion

★ Concealed zip (length depends on size of cushion)

★ Regular zip (length depends on size of cushion)

★ Regular zip foot

★ Concealed zip foot

LEVEL: INTERMEDIATE

DRAFTING A PATTERN

1. This pattern is easy. All you need are the cushion measurements. Mine was 45 cm x 45 cm (17¾ in x 17¾ in).

2. Then add 2 cm (¾ in) for the seam allowance, giving you 47 cm x 47 cm (18½ in x 18½ in). If your pad is particularly full and rounded, add an extra 1 cm (½ in) to each side for ease.

3. Draw out a square or rectangle to your measurements. Then on one of the edges add an extra 5 mm (¼ in) seam allowance for the zip. Label this 'BOTTOM EDGE'.

4. Label the whole piece 'ZIP CUSHION, FRONT AND BACK, CUT TWO'.

MAKING

REGULAR ZIP VERSION

The seam allowance is 1 cm (½ in) except the bottom edge, which is 1.5 cm (⅝ in).

5. You need a zip that is slightly longer than the bottom edge of the cushion.

6. Pin the two pieces, right sides together, along the bottom edge.

7. Take the zip and put a pin in the zip tape, 5 mm (¼ in) from the slider. Position the pin so that it is 3 cm (1⅛ in) from the edge. Ⓐ

8. Measure in 3 cm (1⅛ in) from the other edge. Put a pin in the zip tape.

9. Make notches at these points (3 cm (1¼ in) pins) through the zip tape and both layers of fabric.

10. Now you are going to stitch the seam closed but using different stitch lengths. Starting at the beginning, stitch up to the notch with a 1.5 cm (⅝ in) seam allowance. Backstitch at the beginning and again at the notch. Change your stitch length to the longest option and stitch along the seam to the next notch. This part will get unpicked once the zip has been sewn in. At the notch, change the stitch length back to average (2.2–2.5) and stitch to the end, backstitching at the notch as before and again at the end of the seam. Press the seam open.

11. Keeping the zip closed, place face down onto the back of the seam. Line up the notches. The zip teeth should be sitting on the seam.

12. Pin across the zip, holding it in place on the seam. Make sure you put a pin

in at the two notches. You need this to mark where the notches are when you're sewing. **B**

13. Flip to work on the right side. Pin vertically through the tape and fabric, with pins facing up on one side of the seam and down on the other. **C**

14. Move the pins marking the notches on the back to the right side of the fabric. Holding your thumb in place to mark where the pin is, remove the pin from underneath and secure it on top.

15. Attach the zip foot to the machine. Begin sewing from the top end of the zip, where the slider is. Start on the side of the zip where the pin heads are facing away from you – this makes them easier to remove when sewing.

16. Line up with the notch pin. Get as close as you can to the slider without pushing it to the other side of the seam. When ready, lower the presser foot and remove the notch pin and the first vertical pin. Backstitch to secure the start. Stitch as straight as possible, taking pins out as you go. Don't let the stitch creep closer to the seam.

17. When you reach the bottom notch pin, remove it and visualise where it was. Stitch to this point, then pivot to stitch across the zip to the other side. Pivot back to stitch the other side, keeping the same distance from the seam.

18. When you are level with where you started, pivot and stitch across the top of the zip until you meet the starting point. Backstitch to secure.

19. Unpick the seam so the zip appears. **D**

20. Place right sides together and pin the three sides. Stitch all the way round, pivoting at the corners.

21. Cut off the corners. If you are using fabric that will easily fray, overlock or zigzag the seams together.

22. Turn the right way out and press.

CONCEALED ZIP VERSION

The seam allowance is 1.5 cm (⅝ in).

23. You need a concealed zip that is the same length or up to 10 cm (4 in) shorter than the bottom cushion edge.

24. Along the bottom edge of both front and back cushion pieces, measure in 6 cm (15 in) from each bottom corner and mark with two notches. **D**

25. Press a 1.5 cm (⅝ in) seam allowance along the bottom edge on both pieces.

26. Place the front cushion right side up. Open the zip and place one side face down along the bottom edge. The teeth should sit on the fold line. The zip should extend beyond the notches. Pin in place with the pin heads facing away from the top of the zip. **E**

27. Using a regular zip foot, tack the zip in place, stitching down the middle of the tape in between the notches.

28. Attach a concealed zip foot. Feed the teeth into the channel on the foot, peeling them back so that you are lined up in the groove. Stitch in place, keeping within the notches. **F**

29. Close the zip. Transfer the position of the notches on the fabric to the unstitched side of the zip.

30. Place the back cushion right side up. Open the zip. Place face down along the bottom edge. Align the notches and pin with the pin heads facing away from the top of the zip.

31. Stitch the zip in place; see steps 27–28.

32. Place the front and back pieces right sides together and pin the 3 remaining edges. Attach the regular foot. Starting at the bottom corner, stitch all the way around with a 1 cm (½ in) seam allowance, pivoting at the corners.

33. Then using a regular zip foot, close the gaps on either side of the zip on the bottom edge of the cushion. Starting from the bottom corners, stitch towards the zip, pulling it out of the way so that you can get as close as possible to meet the zip stitching.

34. Cut off the corners. If using fabric that will fray, overlock or zigzag the seams together.

35. Turn the right way out and press. **G**

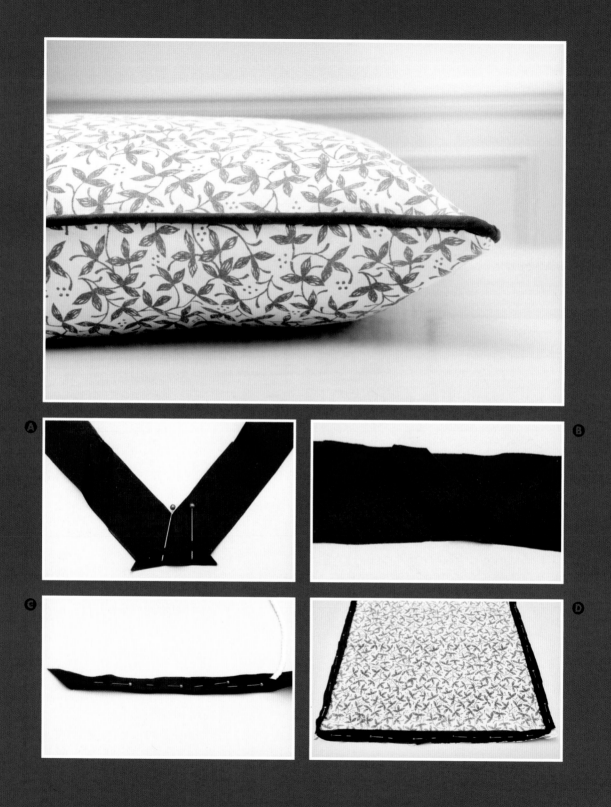

Piped
CUSHION

This fabric is from a vintage shop in Stockholm. There was only 1 m (40 in) left but that was enough for me to make two 40 cm x 40 cm (15¾ in x 15¾ in) piped cushions. I find that these cushions look a bit more professional. I learnt this technique from our soft furnishings teacher, Bevelee.

YOU WILL NEED

★ Vintage fabric for cushion pieces (amount depends on size of cushion)

★ Plain lightweight cotton for bias strips (amount depends on size of cushion)

★ Piping cord (size 3)

★ Regular zip approx. length of bottom edge minus 12 cm (4¾ in)

★ Piping foot

★ Zip foot

LEVEL: ADVANCED

THE PATTERN

1. Follow the instructions for the zip-fastening cushion on pages 143–145 to make a pattern but make sure all seam allowances are 1.5 cm (⅝ in) not 1 cm (½ in). If your pad is particularly full and rounded, add an extra 1 cm (½ in) to each side.

2. Cut out the front and back pieces and along the bottom edge of both (this can be any side if your fabric doesn't have a direction), measure in 6 cm (2½ in) from the bottom corners and create a notch. Then fold over 1.5 cm (⅝ in) along the bottom edges and press.

MAKING

The seam allowance is 1.5 cm (⅝ in).

MAKING THE PIPING

The bias is 45 degrees from the selvedge.

3. To calculate how much piping cord you will need, measure the four sides of the cushion and add together. Then add a further 4 cm (1½ in) for overlap.

4. You will need the same length of bias as the piping. To create the bias strips, mark out 4 cm (1½ in) wide strips on the bias (I used a pattern master to help me do this) and cut out the strips.

5. Join the strips so they become one long strip. Place one bias-cut strip on the table, right side up. Place another strip, right side down, on top of it. Align the short ends of the strip, allowing the pointed ends to extend out either side – they must extend for the same amount on each side. Ⓐ

6. Then stitch from the groove or 'V' on one side to the same point on the other, keeping parallel to the edge.

7. Press the seam open. Trim points. Ⓑ

8. Continue joining strips until you have a piece long enough for the piping.

9. Place the bias strip on the table, wrong side facing up. Lay the piping cord in the middle of the strip. Fold

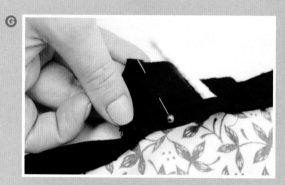

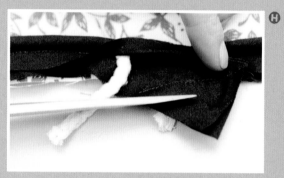

the fabric over the cord, keeping it centred and align the raw edges of the strip. Pin in place. **G**

10. Attach the piping foot to your machine. Lower the foot down onto the piping, ensuring that the piping is sitting in the arc of the foot. Starting 8 cm (3¼ in) down from one end, stitch along the edge of the piping. Then stop 8 cm (3¼ in) from the end. Do not backstitch at the start or the end.

ATTACHING THE PIPING

11. Place the cushion front (if different from the back) right side up on the table. Starting at the side, place the piping raw edge to raw edge with the cushion. Place the first pin 8 cm (3¼ in) from the end of the piping. Pin all the way round, leaving the last 8 cm (3¼ in) unpinned. **D**

12. Clip into the bias strip at the corners to allow the piping to sit flat.

13. Stitch in place, pivoting at corners. **E**

JOINING THE ENDS OF THE BIAS STRIP

14. Remove from the machine and place on the table. Pinch the seam allowance of the piping casing together and overlap the ends. Snip off the excess of the longer end so that the piping ends overlap by 4 cm (1½ in).

15. Pull the piping cord out of the way. Holding each end of the bias strip, turn the left-hand piece so that the wrong side is facing you and turn the right-hand piece so that the right side is facing you. **F**

16. Overlap the pieces so that the short end of the left-hand piece lies along the long edge of the right-hand piece of the piping. Place a pin vertically from the point. **G**

17. Stitch from the left-hand corner to the right. Trim the excess seam allowance and press open.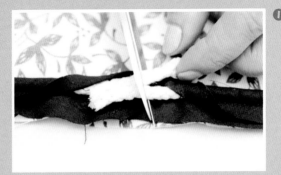

18. Overlap the piping cord and cut right through the middle. Tuck back inside the bias strip and stitch closed.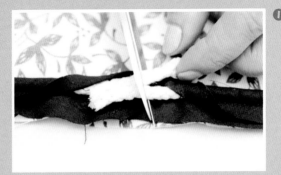

INSERTING THE ZIP

19. Press over 1.5 cm (⅝ in) along one edge of back cushion (pressing over to the wrong side).

20. Place the back of the cushion on the table, right side up. Place the zip face down between the notches, 5 mm (¼ in) from the raw edge. The teeth of the zip should sit level with the pressed line. Put one pin in to secure the positioning.

21. Now open the zip and pin the rest. Attach the zip foot to your machine. Stitch in place from notch to notch.

22. Place the piped front cushion piece on the table, right side up. Place the back cushion down onto the front cushion, right sides together, matching the notches along the bottom edge.

23. Place the other side of the zip face down, 5 mm (¼ in) from the raw edge, this time with the teeth on top of the piping. Pin to secure the position, then open up the zip and pin the rest of the zip. Stitch in place as before.

24. Keeping the front and back cushions aligned, pin the three remaining edges together.

25. Re-attach the piping foot to your machine. Start stitching at one end of the zipped edge. Place the cushion cover under the machine and manoeuvre the fabric until the needle is as close to the zip end as possible.

Check this by lowering the needle while the foot is up. If you think you can get it closer to the zip end, then lift the needle and manoeuvre the fabric again until closer. Stitch around the cushion cover, pivoting at the corners as before.

26. At the final edge, pull the zip slider clear of the foot and machine stitch as far up to the zip as possible.

27. Cut off the corners. Turn the right way out and press.

Vintage
FABRIC LAMPSHADE

This project is perfect for small pieces of vintage fabric. It is quick and easy to make and requires no sewing at all. Shhh… don't tell anyone!

YOU WILL NEED

★ You can buy drum lampshade kits in different sizes. I used a 30 cm (12 in) drum kit for this. They come with the rings, adhesive panel, double-sided tape and a finishing tool.

★ You need approx. 25 cm x 70 cm (10 in x 27½ in) of fabric

LEVEL: EASY

MAKING

1. Iron out any creases in the fabric and lay the fabric wrong side up on the table.

2. Peel back the paper from the adhesive panel at one end. Place the sticky side down onto the fabric. Make sure that the end is lined up straight with the fabric so that as you unroll it stays on the fabric. Continue to peel back the paper as you smooth the panel along the fabric with your hand.

3. Trim away the excess fabric so that it is the same size as the panel. However, on one of the shorter ends, leave an extra 1 cm (½ in) of fabric.

4. Fold over the top and bottom edges of the panel, along the scored lines, until they snap, then peel them away.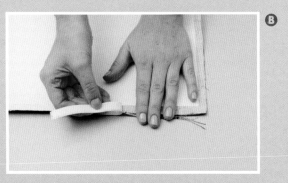

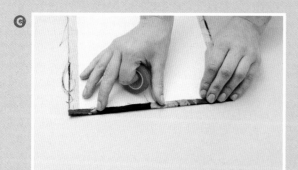

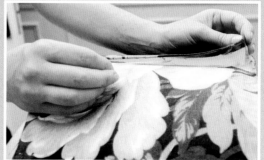

5. Place a strip of double-sided tape at the end of the panel where the extra 1 cm (½ in) of fabric extends. Peel off the plastic and fold over the fabric onto the tape.

6. Place a further strip of double-sided tape on the end of the panel (on top of the fabric). **G**

7. Wrap the double-sided tape around the two rings. The ring should sit centrally on the tape so that you can wrap the tape around the edges. **D**

8. Peel off the plastic on the tape on the rings and position the two rings at the non-taped end of the panel. The rings should sit right on the edge of the panel but not over the edge. The ring with the light fitting needs to be facing inwards. Also make sure that your fabric is facing the right way up – the ring with the light fitting should be at the bottom of the lampshade and the pattern on your chosen fabric.

9. Start to roll the rings simultaneously. The panel will then stick to the rings. **E**

10. Before you reach the end, peel off the plastic from the tape at the end so that as you overlap the beginning and end they stick. **F**

11. Fold the fabric over around the rings. On the ring with the light fitting, you will need to make snips where the bars are to allow you to wrap the fabric around these points.

12. Tuck the raw edges of the fabric in between the rings and the panel. You can use your thumbnail or the provided tool.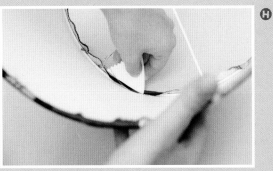

Templates

POUFFE

13CM (5IN)

13CM (5IN)

TOP PANEL

ENLARGE BY 200%

13cm (5in)

13cm (5in)

SIDE PANEL

Index

My favourite shops

SPECIALIST ITEMS

FOR BEADS, STONES AND JEWELLERY FINDINGS:

Creative Beadcraft
1 Marshall Street
London
W1F 9BA
www.creativebeadcraft.co.uk

FOR FASCINATOR SUPPLIES:

Atelier Millinery
2.16 Second Floor
Kingly Court
London
W1B 5PW
www.ateliermillinery.com

FOR FAUX FUR:

A-One Fabrics
50–52 Goldhawk Road
London
W12 8DH

Fabrics Galore
52–54 Lavender Hill
Battersea
London
SW11 5RH
www.fabricsgalore.co.uk

FOR LAMPSHADE KITS:

www.needcraft.co.uk

FOR LEATHER AND LATEX GLUE:

JT Batchelor, Ltd.
9–10 Culford Mews
London
N1 4DZ
www.jtbatchelor.co.uk

Walter Reginald
Unit 6
100 The Highway
London
E1W 2BX
www.walterreginald.com

FOR LEATHER BACKER AND FINDINGS:

S&K Leathergoods & Fittings Ltd.
436 Essex Rd
London
N1 3QP
www.skfittings.co.uk

FOR LEATHER STRAPS:

Etsy
www.etsy.com/uk

FOR TULLE:

Cloth House
98 Berwick Street
London
W1F 0QJ
www.clothhouse.com

FABRIC & HABERDASHERY SHOPS

Fabric Godmother
www.fabricgodmother.co.uk
(This is a good all-rounder for both fabric and haberdashery)

Liberty
Great Marlborough Street
London
W1B 5AH
www.liberty.co.uk

MacCulloch & Wallis
25–26 Dering Street
London
W1S 1AT
www.macculloch-wallis.co.uk
(This shop is really good for trimmings – you can also buy veil combs and fascinator combs here)

The Eternal Maker
www.eternalmaker.com
(This is good for fabric and buttons)

The Village Haberdashery
47 Mill Lane
London
NW6 1NB
www.thevillagehaberdashery.co.uk
(This is great for different cottons)

MY SHOPS

If you like the style of the fabrics and the beads that are used in this book, then you will love our stock. We have two shops:

Sew Over It Clapham
78 Landor Road
London
SW9 9PH

Sew Over It Islington
36a Myddelton Street
London
EC1R 1UA

We also have an online shop, where you can find out details about the courses that we run all year round:
www.sewoverit.co.uk

MY BLOG

For more help and guidance, see our blog: www.sewoverit.co.uk/blog

Acknowledgements

This book is what it is because of all the amazing input from my team at Sew Over It. I would like to thank Freia Groves and Julie Johnston for their expert pattern cutting knowledge and great ideas. Working with you was so much fun. Thank you to Kate Underdown for your fabulous millinery expertise. And to Bevelee Regan for teaching me the best way to make a piped cushion! To everyone else who has helped both with the book or with running the show whilst I was writing – you are a dream team!

Thank you to Lizzy Gray for getting this book off the ground and to my editor Louise McKeever for guiding me through. I know how hard you have worked and I am so grateful. To Anita Mangan for her fresh and beautiful design. To the rest of the Ebury team who make it all possible – the sales team, production and PR – many, many thanks.

To my wonderful agent Jane Turnbull, who has been nothing but the best throughout the whole process. We make a great team!

I had so much fun on the photoshoot as I was blessed with Tiffany Mumford's great eye, creative direction and of course photo skills! Tiff, thank you for bringing my book to life. And to Caroline Wren who made me look the best I have ever looked – if only you could be on call!

To my friends and family for your continuous support and enthusiasm towards this book and my Sew Over It adventures.

And most of all, to my Matt. I dedicate this book to you.

With thanks to Amandine café on Victoria Park Road for allowing us to shoot outside of their lovely café.

10 9 8 7 6 5 4 3 2 1

Ebury Press,
an imprint of Ebury Publishing,
20 Vauxhall Bridge Road,
London, SW1V 2SA

Ebury Press is part of the Penguin Random House group of companies whose addresses can be found at global.penguinrandomhouse.com

Penguin
Random House
UK

First published by Ebury Press in 2015

www.eburypublishing.co.uk

A CIP catalogue record for this book is available from the British Library

Copy-editor: Katy Bevan
Design: Anita Mangan
Photography: Tiffany Mumford
Hair & make-up stylist: Carolyn Wren
Illustrator: Helen Friel

ISBN: 9780091947118

Colour origination by Rhapsody Ltd London
Printed and bound in China by
Toppan Leefung

Penguin Random House is committed to a sustainable future for our business, our readers and our planet. This book is made from Forest Stewardship Council® certified paper.